Palm Beach

IN VINTAGE POSTCARDS

Palm Beach welcomes its guests with a warm climate and outstanding hospitality.

POSTCARD HISTORY SERIES

Palm Beach

IN VINTAGE POSTCARDS

Cynthia Thuma

ARCADIA
PUBLISHING

Published by Arcadia Publishing
Charleston, South Carolina

Printed in the United States of America

Library of Congress Catalog Card Number: 2001087613

For all general information contact Arcadia Publishing at:
Telephone 843-853-2070
Fax 843-853-0044
E-mail sales@arcadiapublishing.com
For customer service and orders:
Toll-Free 1-888-313-2665

Visit us on the Internet at www.arcadiapublishing.com

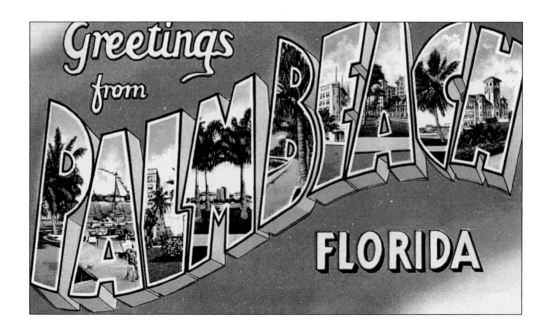

CONTENTS

Introduction 7

1. In the Beginning 9

2. The Flagler Era 13

3. The Mizner Influence 37

4. In Mizner's Wake 49

5. Hospitality and Commerce 55

6. Fun and Games 75

7. The Garden of Earthly Delights 87

8. Education and Religion 103

9. Island Life 117

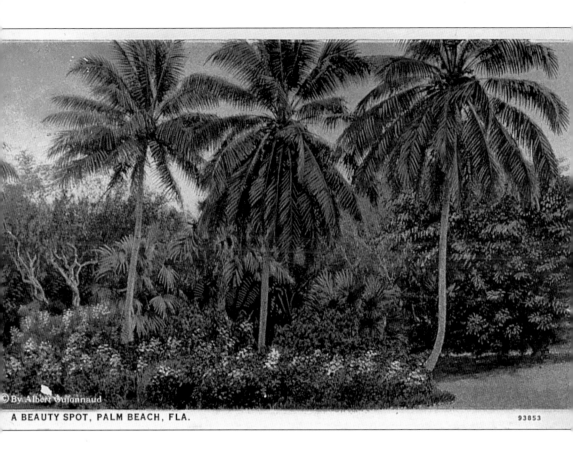

A BEAUTY SPOT, PALM BEACH, FLA.

© By Albert Gulannaud

93853

This book is dedicated to Madgeline Robbins Thuma,
my mother, mentor, and trusted friend.

Thanks to the Reverend Hugh Tobias, pastor of Riverside Baptist Church
in Jacksonville, Florida, and also to Bonnie Wilpon, for her kindness, sage
advice, assistance, and encouragement; Christine Riley, for her graciousness;
and James and Nicholas Young, for their patience and good humor.

INTRODUCTION

A decade or two ago, the state of Florida adopted an advertising slogan that noted "The rules are different here." Surely whoever coined that line had in mind Palm Beach, a 12-mile splinter of high-priced real estate that for every three parts paradise is one part paradox.

The island's first settler was August Lang, a German who settled there to avoid conscription into the Confederate army. The island was the perfect place to hang out and lay low. It was covered with dense tropical vegetation and laden with a variety of game.

The town's name came as the happy result of an accident, when the brigantine *Providencia* went aground on January 9, 1878. The brig's cargo included casks of red wine and 20,000 coconuts. The squatters who lived took care of the wine themselves. Some of the coconuts deposited themselves on the beach, but others were sold off to the island's residents by local salvors at two for a nickel. The result was the coconuts grew rapidly and dotted the island with graceful, stately trees that impressed a visitor named Henry Morrison Flagler, who wanted to find a place where his chronically ill wife could get better and where he could advance his rail lines.

Flagler had failed in some of his early business ventures, but partnering with Samuel Andrews and John D. Rockefeller in Standard Oil had given him an excellent business background and a solid reputation. Flagler fell in love with Palm Beach and recognized its potential value almost immediately.

He was hardly its first settler but put the tiny island town on the map and gave it cachet that endures to the present. He brought the railroad to town and built the Royal Poinciana and Breakers Hotels to hold his guests in the grand fashion to which they were accustomed. Obsessed with permanence and durability in the buildings he commissioned, Flagler likewise laid a durable foundation for the Palm Beach community and for much of southeastern Florida as well.

Addison Mizner's design for the Everglades Club set in motion the wheels of change for Palm Beach. At first, the well-heeled guests came to stay at the hotels. After Mizner—and the other architects, such as Maurice Fatio, Joseph Urban, and John Volk, who followed him—they came to build lavish winter "villas." His designs for homes on Palm Beach set the standard for Florida resort architecture and many remain to this day.

Palm Beach has aged gracefully and well. One no longer needs to be heir to a Fortune 500 company to vacation there, but it still isn't cheap. And it never will be.

P.S. Florida rather quickly dropped "the rules are different here" campaign, but for years, Palm Beach County has been very comfortable with its own marketing campaign. Its slogan is a simple one, easy to remember, and dead-on accurate—Palm Beach County, Florida: The Best of Everything. Henry Flagler would have approved.

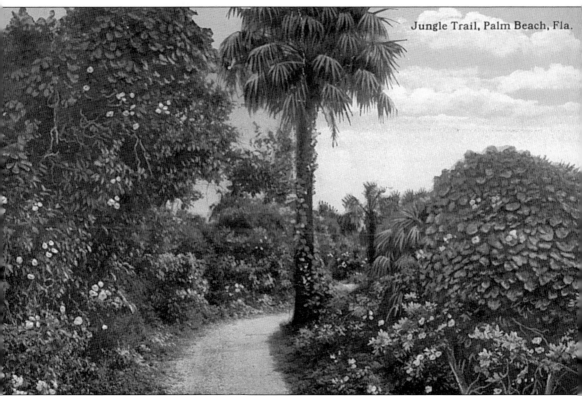

Jungle Trail, Palm Beach, Fla.

Flagler undoubtedly understood his challenge was to celebrate the natural beauty of the island while bringing to it the amenities America's wealthiest citizens had come to expect. This postcard, sent to Spokane in February 1917, notes in part: "we are located here in this beautiful place and everybody is in summer clothing Estelle would rave over this country. I think it is prettier than California."

One

IN THE BEGINNING

The wreck of the *Providencia* left 20,000 Jamaica Tall coconuts from Trinidad. Some washed ashore and grew there. Salvors recovered many of them and sold them—at two for a nickel—to local residents, who planted them in groves and at their homes. Henry Flagler was captivated by the tall, graceful trees that grew so abundantly on the island.

Before the arrival of Flagler and the mansion-building architects, Palm Beach showed promise of becoming a winter resort of a more modest scale. Most of the early homes there were New England–style saltboxes or Victorian-style homes.

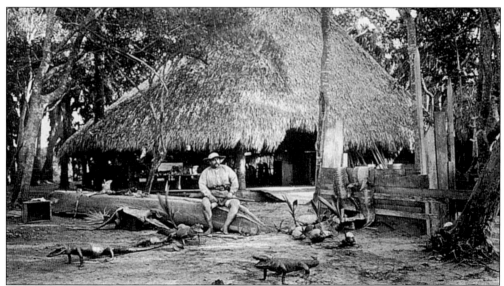

"Alligator Joe" Frazier ran a scenic nature trail and alligator farm and sold real estate on the side. Visitors came to gawk at the manatees and giant sea turtles, watch Frazier wrestle the reptiles, and they often stayed for lunch at his palmetto-thatched pavilion. The property was later purchased for development as the Everglades Club.

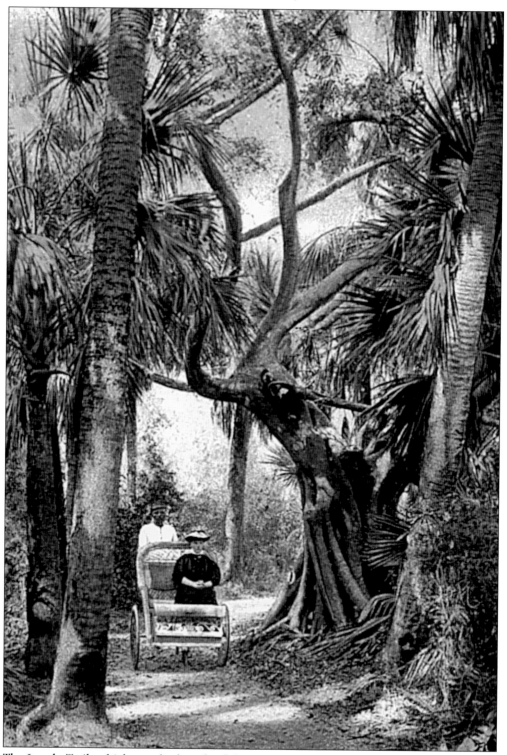

The Jungle Trail, which ran the length of the town, became South County Road and North County Road, the main north-south traffic arteries on the island.

Ocean Boulevard, later the road along which showplace homes were built overlooking the beach, was at first a dirt road without much of a view.

From the Atlantic beach, particularly in Palm Beach County, early settlers foraged for the eggs of the giant sea turtle, which laid them in the sand during high tide at night in the spring and early summer months. The turtles themselves were highly prized for soups and stews. The sea turtles and their eggs are now protected, but despite vigorous enforcement, an underground trade in the eggs continues. Many old-timers believe the eggs enhance male virility.

Two

THE FLAGLER ERA

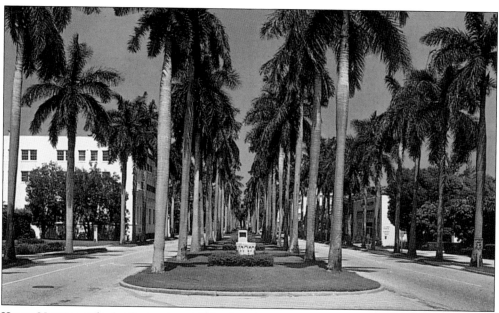

Henry Morrison Flagler first came to Palm Beach in 1878, looking for an optimally beneficial climate for his ill wife, Mary. By most accounts, he was almost immediately smitten with the island and its potential for growth, as well as its suitability for his wife's health. Mary Harkness Flagler died in May 1881 and Flagler married her nurse, Ida Shourds, in June 1883. In 1882–1883, he returned to Palm Beach, this time with blueprints, plans, and lots of cash to carry them out. At that time, there was but one place for lodgers, the 50-room Coconut Grove House, built by Elisha Newton "Cap" Dimick in 1880. Guests paid $6 daily for room and full board. Dimick, who purchased the island from the state, was very active in town politics from the start as its first mayor, and later, he was elected to the Florida Senate. A statue commemorating Dimick and his contributions stands on Royal Palm Way.

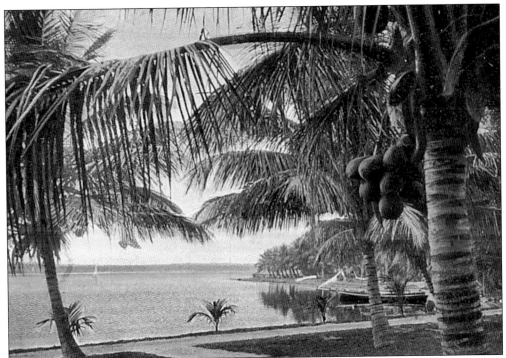

One of Flagler's first purchases was Brelsford Point, a picturesque plot of land on the sheltered side of Lake Worth. It was there that Flagler planned to build his home. He bought the parcel for $50,000 from grocer E.M. Brelsford, who took the profit and built a large home on his remaining piece of land, making him Flagler's neighbor.

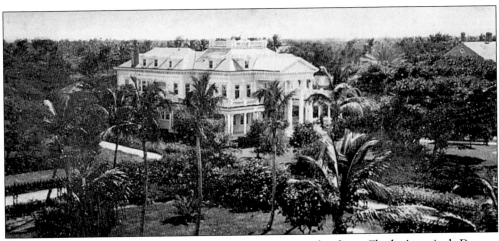

Brelsford was one of the first locals to grow prosperous thanks to Flagler's arrival. Denver grain magnate Robert McCormick sold a significant tract to Flagler, too, including the Albert Geer family homestead, purchased in 1876 for 85¢ an acre.

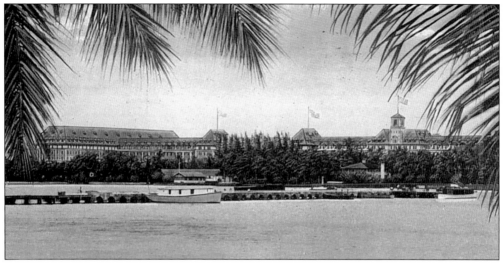

Ground was broken for the Royal Poinciana on May 1, 1893, and the actual construction of the first phase of the six-floor hotel was completed in nine months with 540 rooms but only a handful of guests. A month after the hotel's opening, the railroad link there was completed and the occupancy rate swelled. When totally complete, the hotel was the largest wooden structure in the world and the world's largest hotel, with 1,150 rooms. The kitchens, servant quarters, ballrooms, and other service facilities were located toward the rear of the complex, leaving the choicest views facing Lake Worth on the west for the guest rooms. Luxury suites cost $100 a day, but modest accommodations could be had for less than $10 daily.

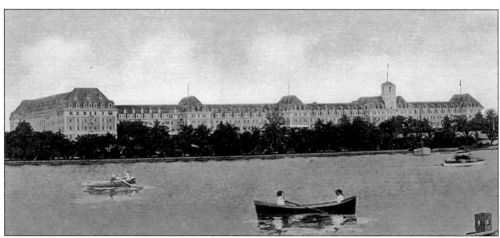

The official opening of the Royal Poinciana was February 11, 1894. Construction required more than 1,400 kegs of nails and nearly a quarter-million gallons of paint. The hotel's exterior was painted yellow with white trim. A staff of 1,400 attended to every whim of the guests. The dining rooms, during high season, employed a battalion of 300 to 400 waiters to serve the dining room's 1,600 guests.

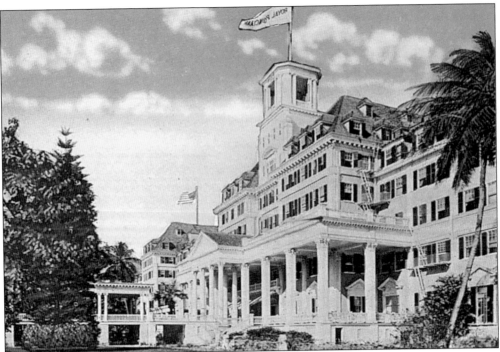

Every architectural facet of the hotel was impressive, from the grand entrance, which was only feet away from the end of the railroad bridge across Lake Worth, to the smaller touches, which included electricity and private baths throughout and elevators for guests' comfort. Many wealthy visitors to the Royal Poinciana traveled on their own private railway cars and parked them on sidings alongside the hotel.

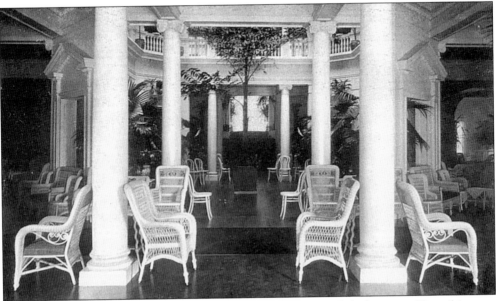

The interior of the Royal Poinciana was elegant in white and dark green. The white was reflected in the wicker furniture used throughout common areas. Green velvet was used on seat cushions and other upholstered pieces.

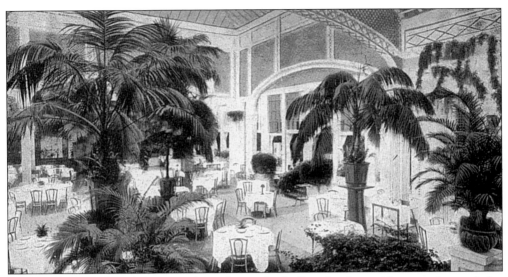

The wide use of white at the grand hotel gave the feeling that it was always spring and also started a fashion trend. Clothing store proprietor Augustus P. Anthony, whose family's store, Anthony's, was near the Royal Poinciana, in 1895 was the first to offer white men's and women's shoes. Before that, shoes were produced in darker, more neutral shades, such as black, brown, and gray. Anthony's, still a family owned store, remains open today.

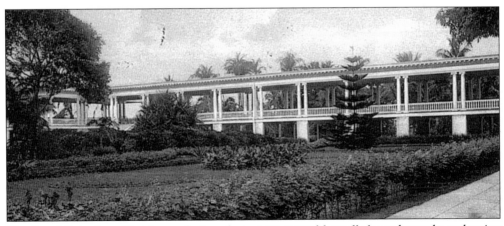

The Royal Poinciana Hotel was designed so visitors could stroll the colonnade and enjoy the beauty of the gardens without undue fatigue. The six-story hotel boasted three miles of hallways and walkways.

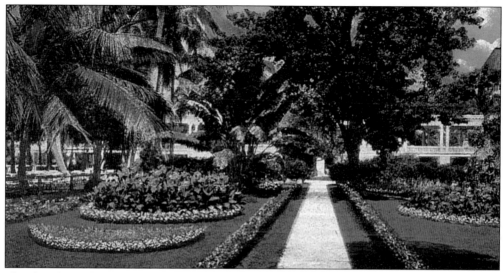

The hotel gardens also were lavishly appointed, meticulously maintained, and laced with sidewalks so guests could stroll among the trees and flowering plants. Flagler directed his gardeners to use the best indigenous plants and to import others to augment the collection.

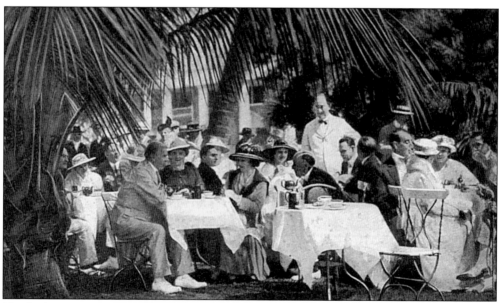

The high point of the day for many was the afternoon tea in the "Cocoanut Grove" in the gardens outside the hotel. The menu was simple: tea, sandwiches, and slices of mouth-watering coconut cake made by a local baker named Mrs. Winter.

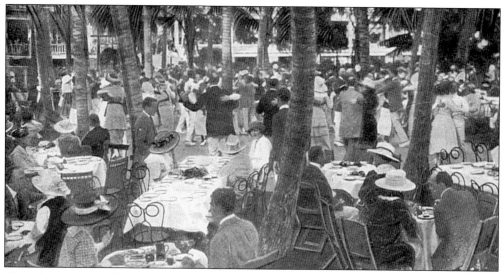

After the tea and cakes were consumed and the tables were cleared, the band began to play and guests could linger in conversation or dance away the afternoon under the palms, which had been strung with stands of lights, until time for supper, about 8 p.m.

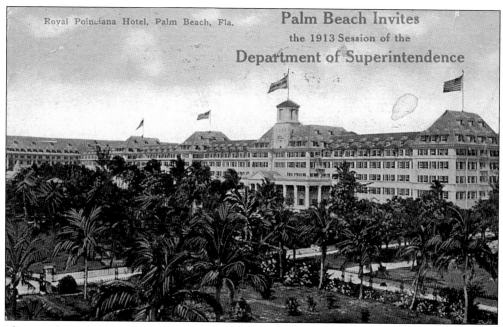

Royal Poinciana Hotel, Palm Beach, Fla.

Palm Beach Invites

the 1913 Session of the

Department of Superintendence

The Royal Poinciana was so massive that porters and room service personnel sometimes answered calls and made deliveries on bicycles. The hotel's popularity caused it to remain filled to capacity and Flagler decided to build another hotel for the overflow. The hotel operated until 1931 and was demolished in 1934.

The Royal Poinciana overlooked Lake Worth, giving guests a grand view of the lake's placid waters and the city of West Palm Beach beyond. Flagler decided his second hotel would be built along the Atlantic side of the island and be the first oceanside resort south of Daytona Beach.

In March 1884, Flagler's Florida East Coast Railroad (FEC) reached West Palm Beach. Flagler constructed a railroad and wheelchair bridge to make it easier for his guests to get to the Royal Poinciana. Trains crossing the bridge backed across. Flagler later added a pedestrian bridge across Lake Worth.

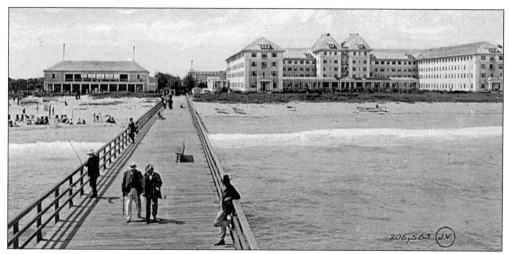

In 1895–1896, Flagler enlarged a winter home to create the first Palm Beach Inn. He also built a 1,000-foot steel pier, the first Port of Palm Beach. Not only was it a fine fishing spot, it also allowed guests the chance to ride the Palm Beach–Nassau Steamship Lines' *Northumberland* to Nassau, Bahamas, as well as Havana, Key West, and Miami.

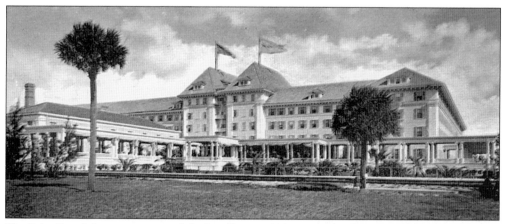

The Palm Beach Inn was renamed the Breakers in 1901. In 1903 a fire consumed the building, but it was quickly re-erected. This card shows where Flagler extended his private railroad line to a circular route in front of the building. After bringing his railroad to Palm Beach, he continued his drive south toward Key West. The Florida East Coast Railroad's first train to reach Key West, the "Flagler Special," arrived there on January 22, 1912. Henry Flagler, nearly blind and deaf, died the next year from declining health and injuries suffered from a fall at Whitehall. Opening the link to Key West was probably Flagler's brightest moment. Railroad service to the Keys ceased on September 2, 1935, when a hurricane struck the Keys and destroyed much of the 156-mile single-track short line. The tracks were never rebuilt.

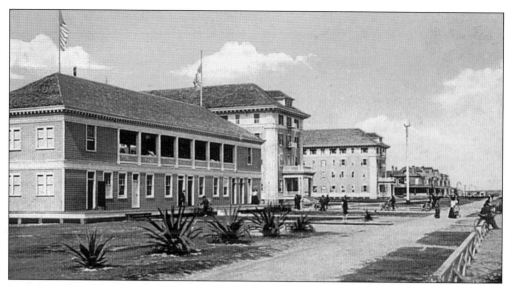

Unlike the Royal Poinciana, the Breakers boasted of a series of oceanside cottages for special guests. The cottages were named Ocean View, Surf, Wave Crest, Reef, Nautilus, and Atlantic. Located north of the hotel building, they provided full service and enhanced privacy. The 1925 fire that consumed the hotel was a spectacular blaze that caused many of the residents and visitors to turn out and gawk.

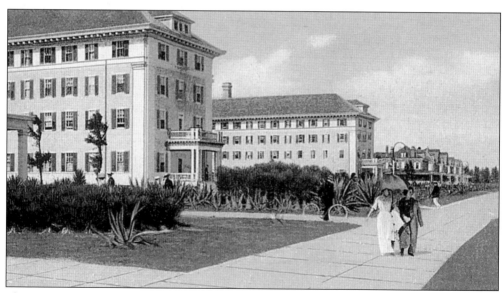

The Breakers was painted yellow, as were all of Flagler's wooden hotels and FEC train engines. Its spacious promenade offered a beautiful beach vista. The Breakers cottages are visible just beyond the hotel. After his fall at Whitehall in 1913, Flagler, then 83, lived his last days at Nautilus cottage.

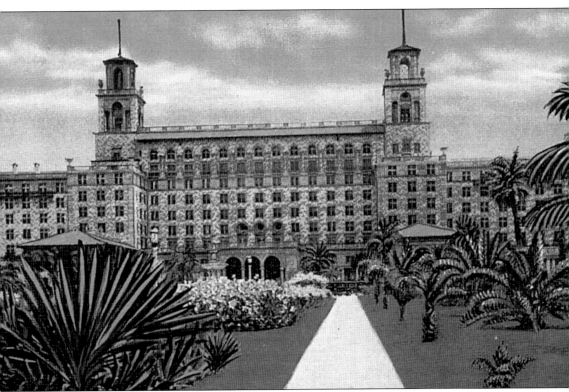

After the 1925 conflagration, the Breakers was replaced with the majestic H-shaped edifice with twin towers that stands today. The eight-story hotel was designed by the architectural firm Schulze and Weaver, designers of New York's Waldorf-Astoria Hotel. The distinctive two-tiered towers can be seen for miles. A golf course, tennis center, and championship-quality croquet greensward are on the premises. The Breakers was listed in the National Register of Historic Places on August 14, 1973.

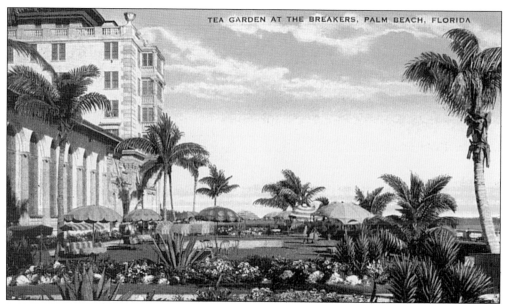

TEA GARDEN AT THE BREAKERS, PALM BEACH, FLORIDA

The Breakers also features a variety of outstanding restaurants, chic shops, and a beautiful courtyard with sunken garden. In earlier days, the tea garden featured cabanas that allowed guests to enjoy the warmth of the sunshine without suffering sunburn.

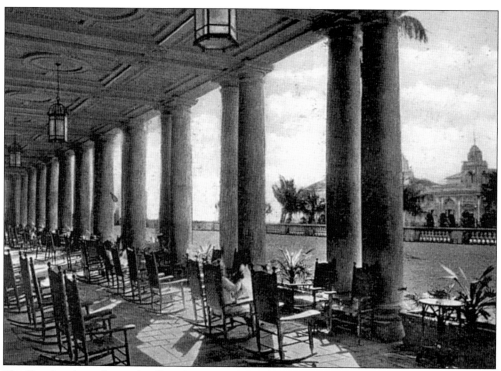

The Breakers' south porch offered a peaceful spot in which guests could relax and enjoy the day's paper, a light breakfast, and a lovely view of the casino.

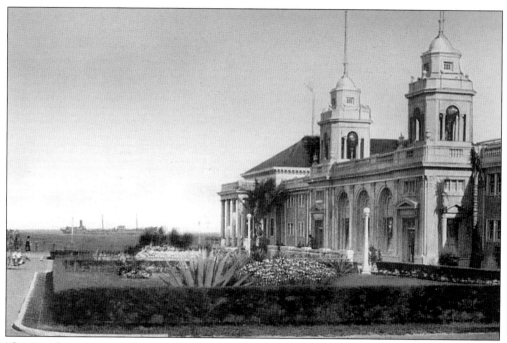

The Breakers' casino, for use by the hotel's guests, was located just south of the main building, across Oleander Avenue, and offered a beautiful view of the Atlantic. The casino, like all amusements on Flagler's property, was closed on Sunday.

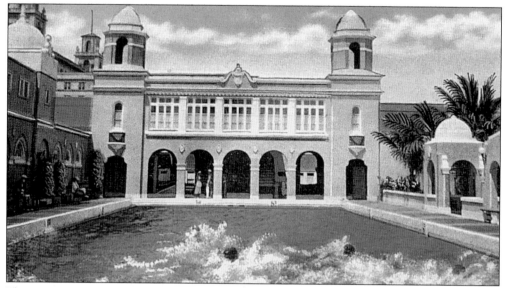

The casino swimming pool allowed guests at the Breakers the chance to enjoy swimming, yet avoid the inconvenience of seaweed, men-o-war, and undertow. Women who chose to swim at the pool or the beach wore heavy, black swimsuits that extended from the neck to the ankle.

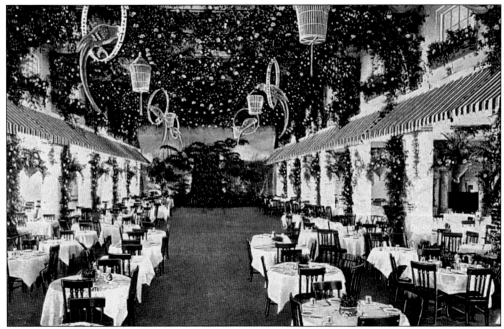

The Breakers' dining room was lavishly decorated, and like the Royal Poinciana, offered an outstanding selection of foods prepared by a battalion of chefs.

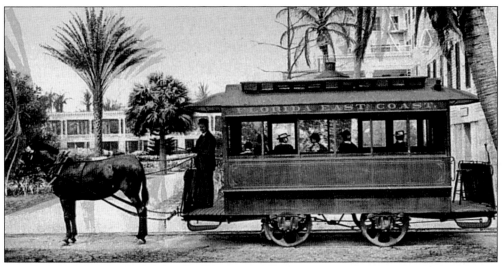

Flagler also commissioned the creation of a mule car shuttle between a spot just north of the Royal Poinciana and the Breakers. The mule car had no horn, but the sound of the braying mule heralded its arrival. The trip cost 5¢ and the route it took eventually became known as Piney Lane. The thoroughfare, now known as Pine Walk, still exists.

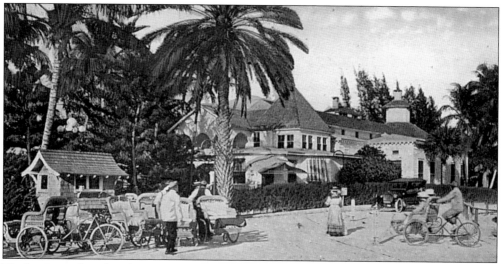

Flagler invited Col. Edward Riley Bradley, who had partnered with him and Bradley's brother John in the Bacchus Club in St. Augustine, to open an exclusive gambling house on Palm Beach. Membership in the casino, formally known as Bradley's Beach Club, was closed to island residents. Longtime visitors to the Royal Poinciana, located between the casino and the Royal Poinciana Chapel, often joked their accommodations were situated midway between sin and salvation. In this view, bicycle chairs, commonly called afromobiles or Palm Beach coaches, and their drivers await a call.

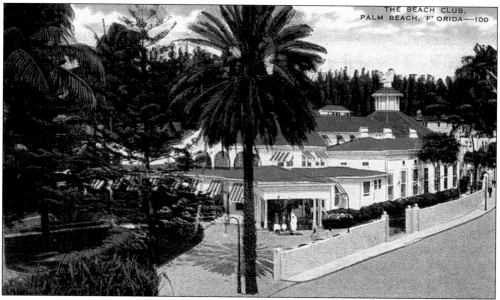

Bradley was a sportsman of near-epic proportion and the owner of the Idle Hour Farm in Lexington, Kentucky and the Fair Grounds Race Track in New Orleans. He was the first stable owner to own four Kentucky Derby winners. He ran his Palm Beach casino between 1898 and 1945 and died a year after the casino closed.

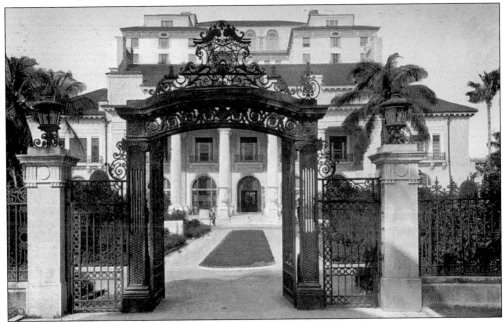

Flagler's palatial home, Whitehall, was built as a wedding gift for Flagler's third wife, Mary Lily Kenan, who was 34 when she married Flagler, then 71, in 1901. The couple met when Kenan, originally from Kenansville, North Carolina, was vacationing at one of Flagler's St. Augustine hotels.

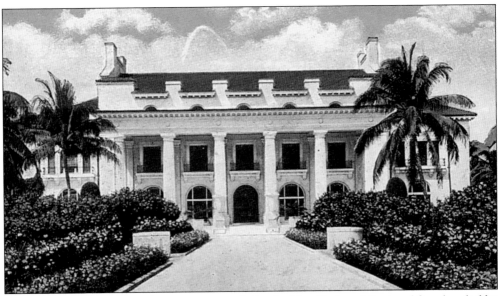

Whitehall was designed in the Beaux Arts style by the New York architectural firm headed by John Carrere and Thomas Hastings. The opulent interiors were designed by the New York design firm of Pottier & Stymus. Whitehall was listed on the National Register of Historic Places in December 1972.

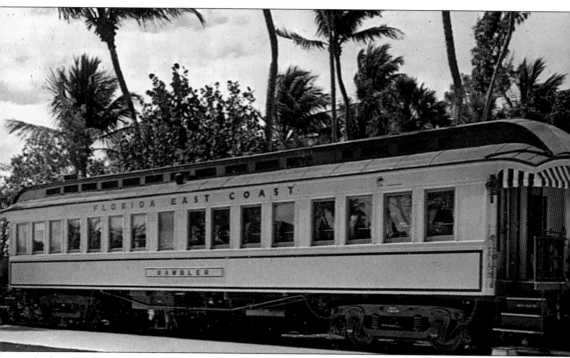

Flagler's personal railroad car, Rambler, is parked on Whitehall's south lawn. The car was built in 1886 and used continuously for 60 years. Its interior was paneled in oak and had a kitchen, lavatory, and shower compartment. The kitchen was compact, yet fully stocked and even provided a pull-down sleeping compartment for the cook. After Flagler's death, the railroad car was used by other railroads until 1949. When officials from the Henry Morrison Flagler Museum attempted to locate it, they were faced with a tough task. In 1959, they located it; its wheels had been removed, it had fallen into disrepair and was being used as a residence by a Virginia tenant farmer. It took seven more years to find the remainder of its original fittings so restoration could begin.

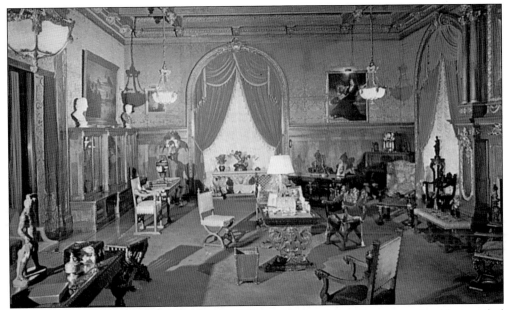

Whitehall's Renaissance Library was paneled in walnut with a damask-and-gold stenciled Italian ceiling. Busts and other sculptures, plus a variety of original paintings, complete the furnishings. Every detail within Whitehall was attended to and appointed with *objets d'art* of uncompromised quality.

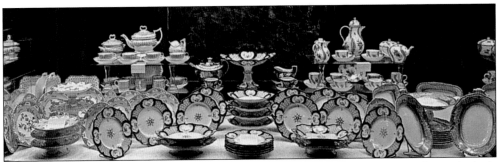

No expense nor detail was overlooked at Whitehall, as shown in the fine china from Flagler's time now on display there. Mary Lily Flagler often gave away beautiful cut-crystal vases and perfume bottles to card-party winners there.

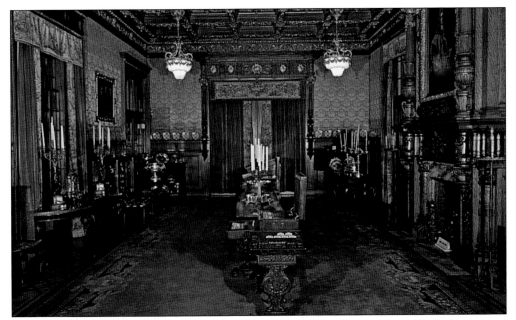

The formal dining room at Whitehall was truly opulent, with silk tapestry walls, delicate wood carvings around the fireplace and mantel, crystal chandeliers, and Limoges service plates.

Whitehall's location on Brelsford Point was close to the Royal Poinciana Hotel and its dock and offered beautiful views of Lake Worth and breathtaking sunsets. The Cocoanut Grove was located between Whitehall and the Royal Poinciana.

Though Flagler is given credit for developing Palm Beach into a community of unparalleled stature, his role in the development of West Palm Beach is no less important. When Flagler began purchasing land in 1892–1893, he did so on both sides of Lake Worth. In 1893, he platted West Palm Beach as a 48-block community. West Palm Beach, which calls itself the "Orchid City," has an impressive history as a city of commerce, tourism and hospitality, and the arts.

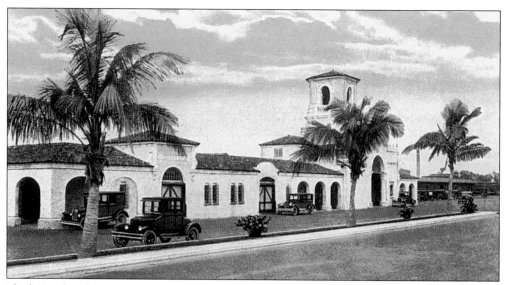

Flagler's Florida East Coast Railway was joined in January 1925 by the Seaboard Air Line Railroad. The West Palm Beach Seaboard station, located at the intersection of Datura and Tamarind, was designed by L. Phillips Clarke and Henry Steven Harvey. The first Seaboard Air Lines train to arrive in West Palm Beach was the Orange Blossom Special, whose name reflected the train's path down the peninsula, where it passed through orange-growing towns such as Winter Haven, Frostproof, Auburndale, and Sebring. The station is now on the National Register of Historic Places.

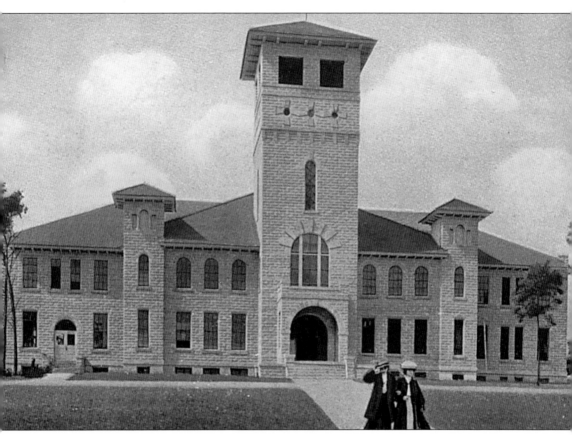

Although he largely envisioned West Palm Beach as the support community for Palm Beach, Flagler was active in developing the community and seeing that facilities such as Central School were constructed. The school was built in 1908; later, parts of it were used in the construction of Twin Lakes High School and still stand today adjacent to the Raymond Kravis Center, although the tower's top was destroyed during the hurricane of September 16, 1928. Flagler also purchased a pineapple field that he transformed into a cemetery, now known as Woodlawn, where he planned to be buried. However, in 1911, West Palm Beach attempted to annex Palm Beach and Flagler reacted angrily, canceling his burial plans. He died two years later at 83 and his remains were taken to St. Augustine for internment with his first wife, their daughter, and a granddaughter.

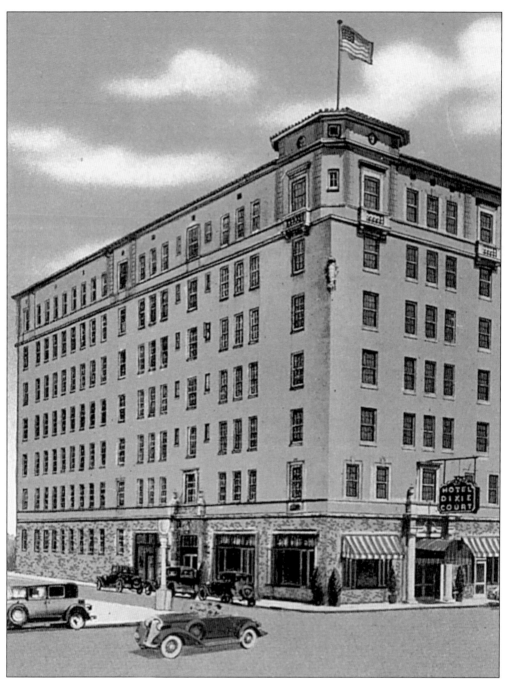

As Palm Beach's hotels, restaurants, and other accommodations prospered, so too did West Palm Beach's. Shown here is the Hotel Dixie Court, designed by the architectural firm of Harvey and Clarke and completed in 1926. Harvey and Clarke specialized in government and commercial buildings and designed several buildings of note on Palm Beach, including the town hall and fire station at 360 South County Road, a row of commercial buildings on the 270 to 280 block of South County Road, another row of shops at 365 South County Road, and the original Palm Beach Daily News building at 204 Brazilian Avenue.

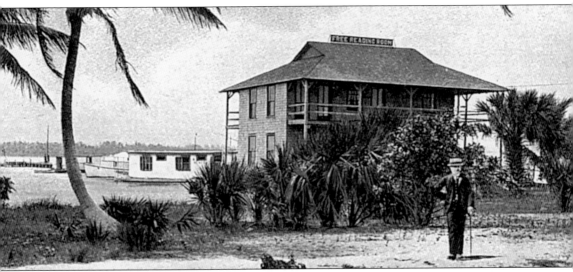

The Free Reading Room in West Palm Beach, the area's first public library, provided a wholesome alternative to drinking and dating for young single men and actually got its start on Palm Beach in the clubhouse of the Palm Beach Yacht Club. The building was towed by barge across Lake Worth and brought ashore at the base of Clematis Street. There, located among the Salt Air and Holland Hotels on one side and the Seminole and Palms Hotels on the other, the reading room and a nearby park functioned as the hub of activity in downtown West Palm Beach. On the reverse, this postcard notes: "For geniality of climate Palm Beach yields to none. Neither Hawaii nor Southern Italy can surpass it. It is situated just across famous Lake Worth from that greatest of all winter tourist resorts, and is the center of the pineapple-growing region of Florida. It is an enterprising city of homes, with many Northern residents."

Lake Worth, just south of West Palm Beach, also prospered as a service community for Palm Beach. Lake Worth was named in honor of Col. William Jenkins Worth, who commanded the U.S. forces in the Second Seminole War.

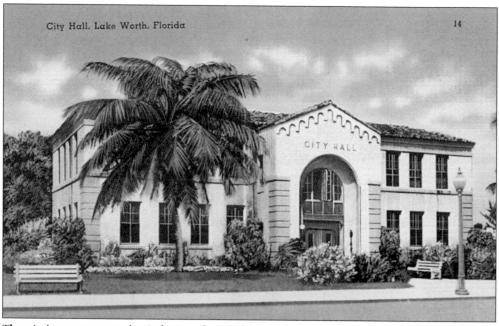

City Hall, Lake Worth, Florida 14

The city's newspaper, the *Lake Worth Herald and Coastal Observer*, began operations in 1912 and is still publishing. Lake Worth got limited electricity and water mains in 1914. The city hall was designed by G. Sherman Childs, an associate of Addison Mizner.

Three

THE MIZNER INFLUENCE

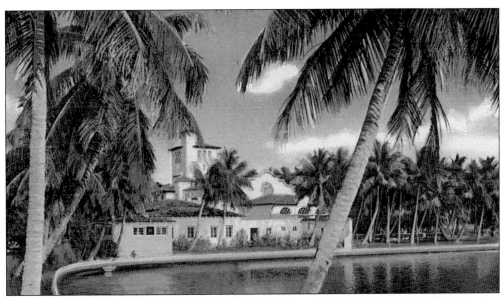

A native of Benicia, California, Addison Mizner first came to Palm Beach at the invitation of Paris Singer. Mizner clearly needed a break. His New York architectural practice was floundering, he was depressed and in poor health. Singer's invitation turned out to be just the tonic Mizner and his career needed. The Everglades Club was the first building he designed in Palm Beach. Originally intended for use as the Touchstone Convalescent Club, for soldiers returning from World War I, owner Singer immediately established it as the most exclusive social club on the island.

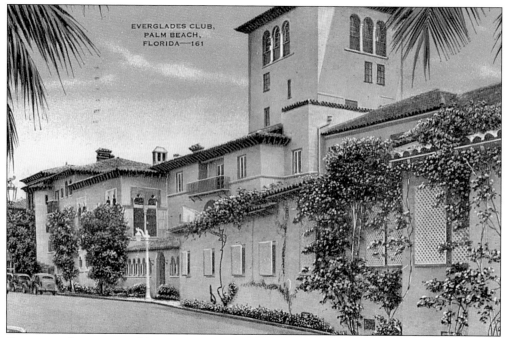

Constructed in 1918 and located near the west end of Worth Avenue, the Everglades Club provided a hint of Mizner's eclectic style. The building contains Moorish, Venetian Gothic, California Spanish, and Venetian influences.

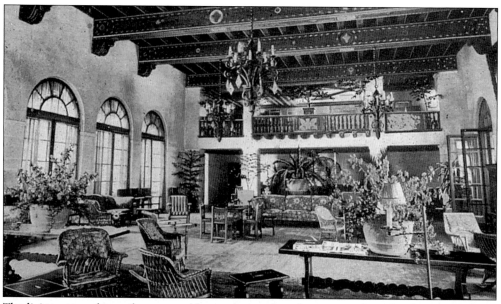

The living room shows the exposed beam design that characterized much of Mizner's work. He usually also designed the interiors and furnishings of the buildings he designed and sometimes also drew the plans for the landscaping.

The Alamanda Walk at the Everglades Club, named for the golden flowering vines planted along the walkway, combined rich architectural design with lush tropical foliage and a superb view over the lagoon at Lake Worth. The walkway led to a series of apartments and sitting rooms upstairs.

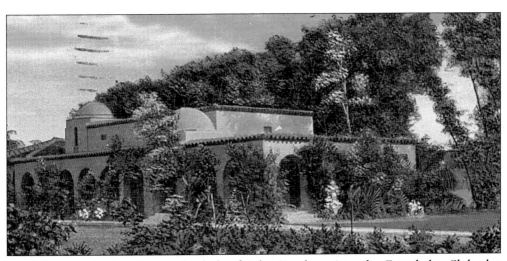

In addition to its function as the hub of Palm Beach society, the Everglades Club also provided its members a golf course and clubhouse.

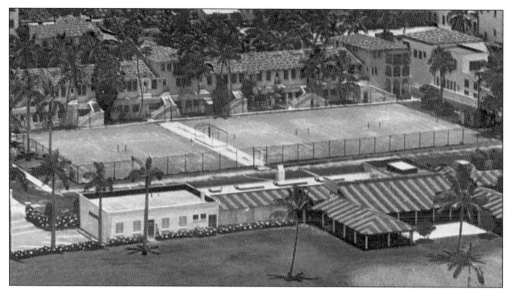

Tennis facilities also were available on site and provided members with a good workout on the courts before an evening of socializing.

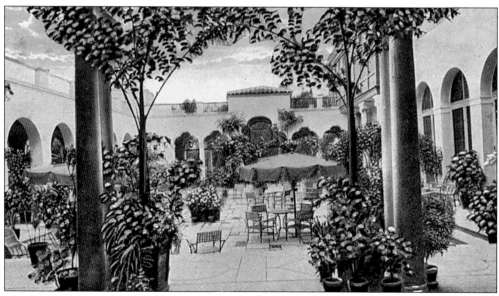

The breakfast room on the Court of Orange's open courtyard allowed members and their guests the opportunity to sip fresh orange juice and eat *al fresco*—something they'd be unlikely to do at their homes in the North.

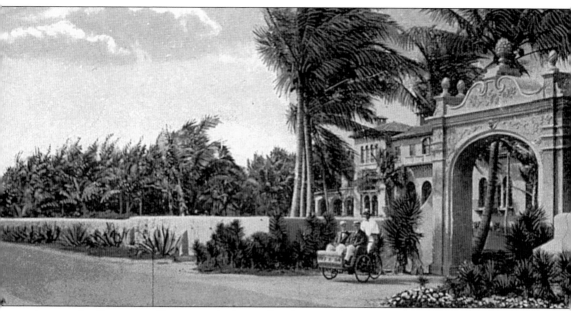

Among the first wowed by Mizner's design for the Everglades Club were investment banker Edward Townsend Stotesbury and his second wife, the former Lucretia Roberts Cromwell, prominent winter residents from Philadelphia. "Ned" and "Queen Eva" were so moved by Mizner's work on the Everglades Club, they fired Horace Trumbauer, the architect who had designed Whitemarsh Hall, their palatial, 147-room main home. They had commissioned Trumbauer to design their winter home before they saw the Everglades Club. Mizner designed El Mirasol (Sunflower) for them. El Mirasol was razed in 1953, and its fittings and furnishings were sold at public auction. El Mirasol and Playa Riente (Smiling Sands), designed for Joshua Cosden, are the two most outstanding examples of Mizner's work that have been demolished.

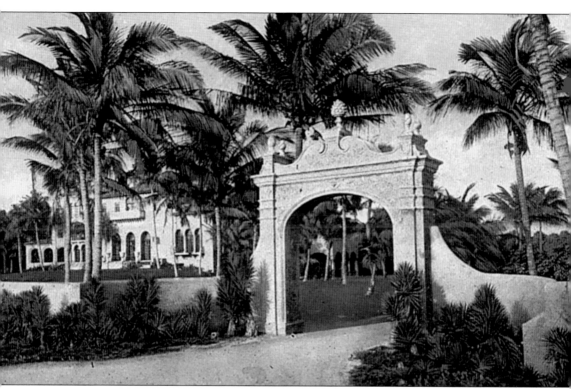

El Mirasol, with 37 rooms, a 20-car garage, and a private zoo, covered 42 acres north of Wells Road on North Ocean Boulevard. The home was completed in time for the 1919–1920 winter season and helped catapult the Stotesburys from near the top of the social ladder to its pinnacle. Eva Stotesbury's daughter from a previous marriage, Louise Cromwell Brooks, married Gen. Douglas MacArthur in the salon facing the ocean there on Valentine's Day in 1922. Her son, James H.R. Cromwell, also married well, first to auto heiress Delphine Dodge, then to tobacco heiress Doris Duke. James Cromwell also served as the U.S. ambassador to Canada.

Mizner's design for El Mirasol featured open loggias, a Moorish tea room and cloister, a sunroom, an auditorium, six patios, and fountains. Its living room alone could accommodate nearly 200 guests. A crew of 15 gardeners was employed year-round to maintain the lawns and gardens.

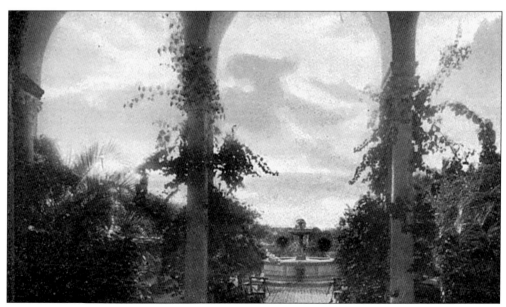

The landscaping at El Mirasol was as impressive as the building. Coconut trees lined one walkway, Australian pines lined another. The patio featured smaller areca palms and bougainvillea. A citrus grove on the property provided a supply of fresh oranges and grapefruit.

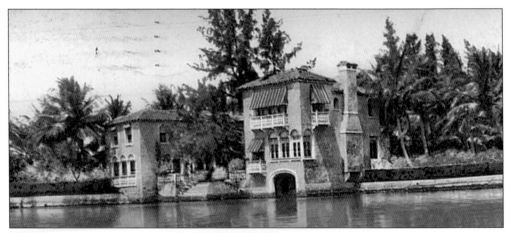

Casa dei Leoni, located just west of the Everglades Club on Worth Avenue, was designed for Leonard M. Thomas and built in 1921. The Venetian Gothic building's name comes from the lion of St. Mark sculpted in low relief over the front door. The home features a boat entrance from Lake Worth.

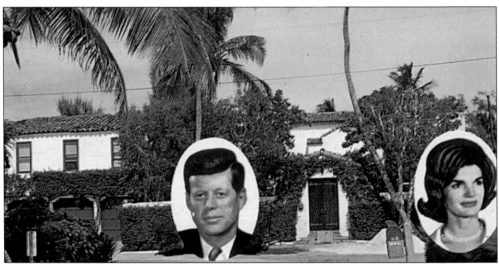

President John F. Kennedy's "Palm Beach White House" on North Ocean Boulevard was designed by Mizner and constructed in 1923 for Rodman Wanamaker. Swiss-born architect Maurice Fatio designed later additions to the home. Joseph P. Kennedy bought the house in 1933. President Kennedy wrote *Profiles in Courage* while recuperating there from back surgery.

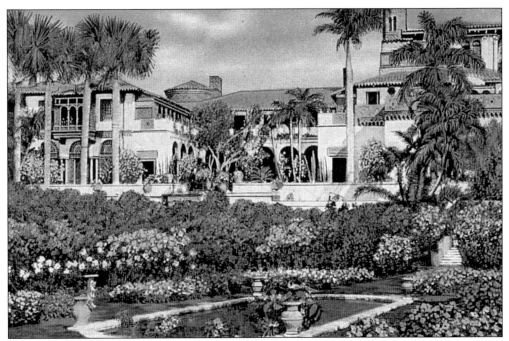

The Woolworth Donahue residence, Casa Nana, was designed by Mizner for the grandson of the five-and-ten store chain's founder. The home also was called Cielito Lindo (Heaven Eyes) after a quartet played the popular song at a party there.

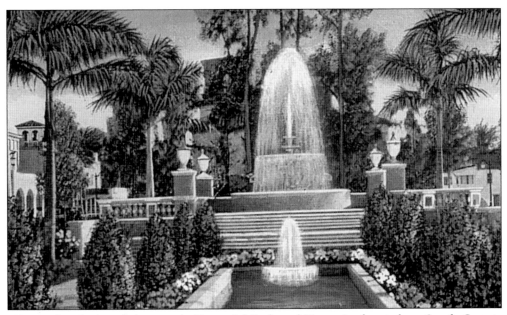

Mizner also designed the town's Memorial Park and Fountain, located on South County Road just north of Worth Avenue. The fountain and the reflecting pool provide an island of serenity in the midst of the hustle and bustle of island life.

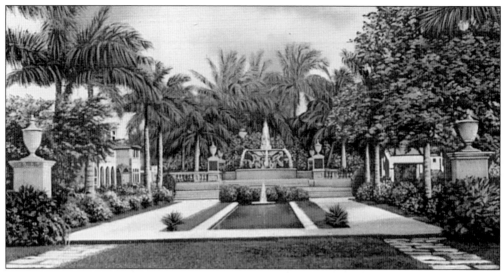

Memorial Park is the largest memorial in town. The park, fountain, and reflecting pool were constructed in 1929 at a cost of $25,000. The fountain is comprised of horse statues at the base with three basins above. Rows of low hedges line the reflecting pool and ring the back of the fountain.

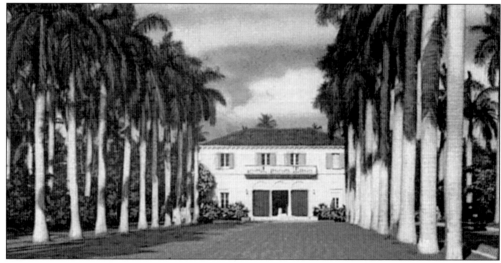

Mizner was one of several prominent architects to work on the Society of the Four Arts buildings. Lester Geisler worked with Mizner on the original building in 1928. John Volk did additional work in 1947. Others who worked on the project included Maurice Fatio, who designed the library in 1936, and Marion Wyeth, who made library additions in 1946. Mizner's personal library and sketchbooks—about 450 volumes in all—are housed in the Society of the Four Arts Library.

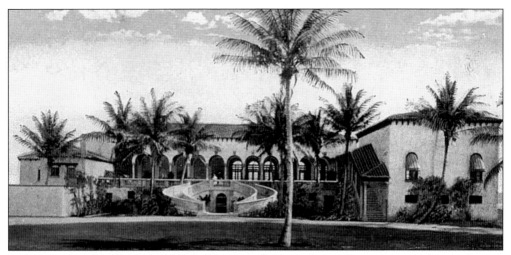

Before moving south to begin work designing the city of Boca Raton, Mizner designed many homes and commercial buildings in Palm Beach and a few in neighboring communities. He built three buildings in Boynton Beach, including the Women's Club building, which still stands. He built a theater in Belle Glade, and his final project in the Palm Beach area was a home for the mayor of nearby Manalapan, called L'Encantada (The Enchanted), built in 1928. In Gulf Stream, he designed the Gulf Stream Golf Club, where many Palm Beachers held memberships.

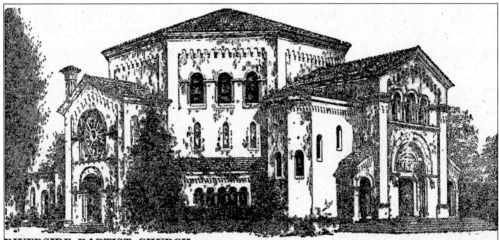

RIVERSIDE BAPTIST CHURCH SE corner King and Park Sts., Jacksonville, Florida, is an octagonal structure of gray limestone blocks with a red tiled roof, embodying features of Spanish and Byzantine architecture. The building was erected in 1925, and Addison Mizner was the architect. Gable wings extend from four sides of the octagon, giving the structure the shape of a cross. The entrance into the front gable, on King Street, is through heavy carved pecky-cypress doors under a graven stone arch, above which is a series of three arched blue windows. Two other entrances into the side gables are through cypress doors under large blue rosette windows. All windows, placed in deep recesses in the thick walls, usually in groups of three, are of blue glass. The effect inside is that of calm blue light diffused from a great height over orderly pews. The only departure from the scheme of blue is a trinity of yellow windows on either side of the rear gable, that cast a golden light upon the choir, enclosed behind iron grillwork back of the pulpit. The central chandelier, copied from one of the Santa Sophia Mosque in Istanbul, has blue glass, to produce the same lighting effect by night as by day. Tile for the floors was brought from an ancient Spanish Cathedral.
—From the American Guide series.

Mizner designed only one church—Riverside Baptist Church in Jacksonville, Florida. He also designed homes in New York, California, Georgia, and Colorado.

Most Mizner homes had several features in common, such as loggias, pecky cypress interiors, and barrel tile roofs. Mizner employed workers to manufacture terra cotta barrel roofing tiles to his specifications. Those tile molds are still used today. Mizner homes also commonly featured courtyards and patios, and the fountains in them, and in the homes' bathrooms, often were decorated with hand-painted ceramic tiles.

Four

IN MIZNER'S WAKE

The success and acceptance of El Mirasol caused a paradigm shift on Palm Beach. Formerly pleased to come down and spend a few weeks in the sun, the wealthy now came to build vacation "villas." Giants of business and industry became infected with a kind of "edifice complex" as they set to work trying to outdo each other's winter home. Sleepy Ocean Boulevard began to come alive as the mansion-builders moved in and the brick-and-mortar competition began. The views along Ocean Boulevard were impossible to be ignored and prime land there was snapped up quickly.

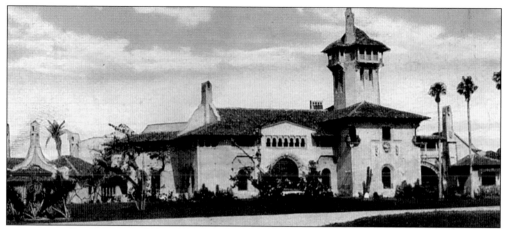

Mar-a-Lago, at 114 rooms undeniably Palm Beach's most opulent home, was designed for cereal heiress Marjorie Merriweather Post and her second husband, financier Edward F. Hutton, by Joseph Urban and Marion Wyeth and constructed in 1924–1927. Its name comes from the fact that the property stretches from the ocean to Lake Worth. Mar-a-Lago was named a National Historic Landmark in 1972. Donald Trump is its current owner.

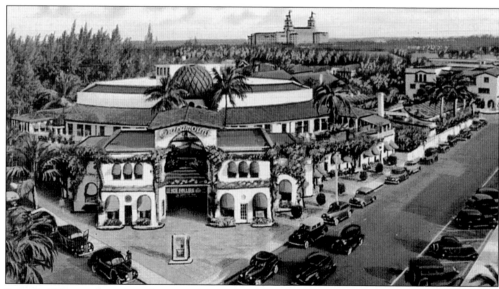

Joseph Urban, who trained in Austria and had also done work as a stage designer, drew heavily on his theatrical background in his plans for the Paramount Building and Theater, which opened in 1927 and still stands today. A feature of the theater was the floor-to-ceiling murals of deep-sea life that Urban created.

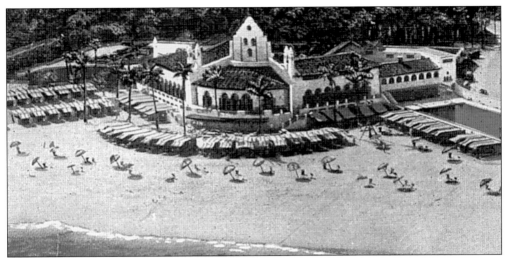

Just across the street from Mar-a-Lago, Urban designed the Bath and Tennis Club to rival the Everglades Club as the island's premier sports, dining, and social club. Begun by Marjorie Merriweather Post, the club originally met at the Breakers Hotel. The club complex was constructed in 1926 at the place on the beach where the *Providencia* had run ashore a half century earlier. Additions to the Bath and Tennis Club were designed by Marion Wyeth and John Volk.

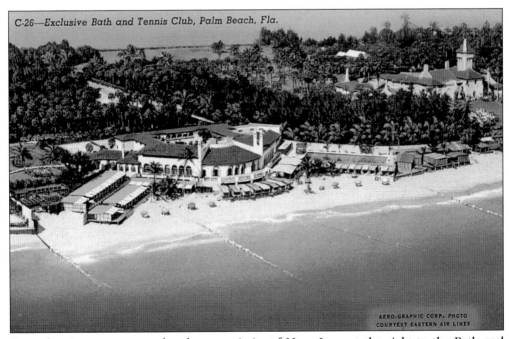

C-26—Exclusive Bath and Tennis Club, Palm Beach, Fla.

From the air, one can see the close proximity of Mar-a-Lago at the right to the Bath and Tennis Club. South Ocean Boulevard separates the two properties.

The First National Bank building in Palm Beach County, at 255 South County Road, was designed by Maurice Fatio, with additions in the 1930s and 1970s by John Volk. It is the oldest bank in Palm Beach County. One employee who worked on President Frank Shaughnessy's staff there on opening day in 1927, Helen Sowell, retired in 1974 as senior vice president.

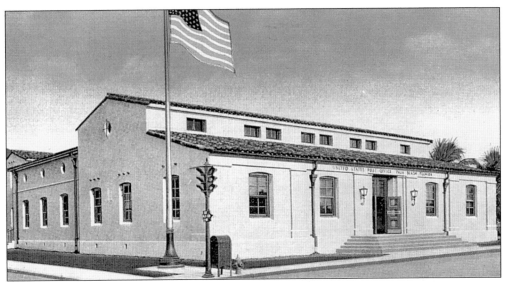

In Palm Beach, even the government buildings are distinctive. The main post office for Palm Beach, located at 95 North County Road, was designed by Louis A. Simon and completed in 1937. It was listed on the National Register of Historic Places on July 21, 1983. The Charles Rosen murals inside depict the lives of Seminole Indians in the Everglades.

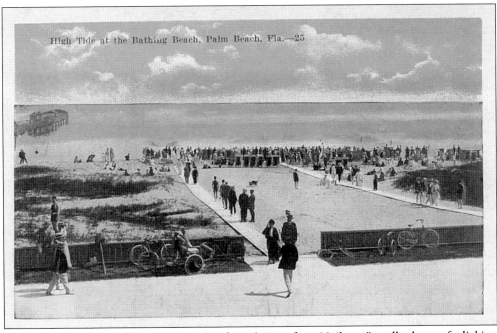

Twice a week, from 1885 to 1893, the famed "Barefoot Mailman" walked past frolicking Palm Beachers as he made his trek along the Atlantic beach from Jupiter to Cape Florida on Key Biscayne. The round trip took six days. Among those who walked the route were H.J. Burkhardt, Ed Hamilton, Edwin R. Bradley, and his sons Guy and Louis.

Winter residents who built more modest accommodations for themselves tended to favor the Spanish/Mediterranean design of the larger mansions.

For winter residents or year-round "townies," an entire village of modest winter villas was constructed in a cluster along North Lake Trail.

Five

HOSPITALITY
AND COMMERCE

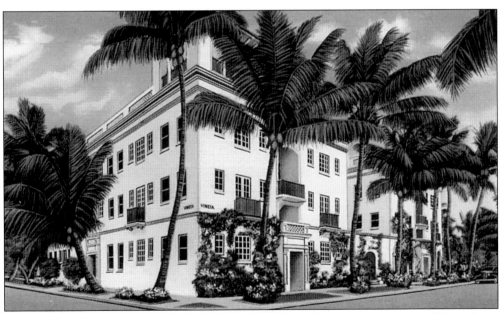

Palm Beach's first hotel was not the Royal Poinciana, of course, but it might well have been since it set a world-class standard for luxury and service. Flagler's resorts ruled the island among high society, but gradually, other lodgings were built to allow guests of other means to participate in the Fantasy Island lifestyle. The Vineta Hotel was built in the Mediterranean style in 1926, and John Volk designed an addition in 1937. The hotel later became known as the Palm Court Hotel and was listed on National Register of Historic Places in 1986.

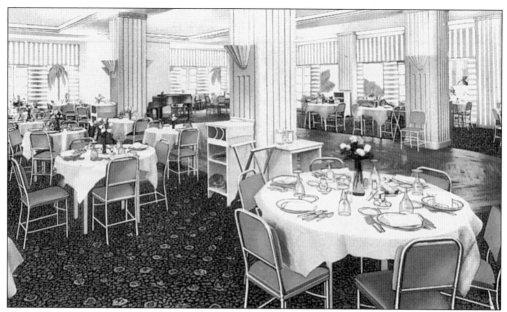

The Vineta, at 363 Cocoanut Row, is at the intersection with Australian Avenue. Its bright, airy interior, such as shown in the dining room, featured modern furnishings, but the service was strictly old-world style.

When the Breakers Hotel burned down in 1925, some of the embers set another island hostelry, the Hotel Palm Beach, afire, too. Few guests were injured because many had gone to watch the Breakers burn. Sidney Maddock, the Hotel Palm Beach's owner, decided to build a more luxurious hotel, the Palm Beach Royal, on the site of Hotel Palm Beach.

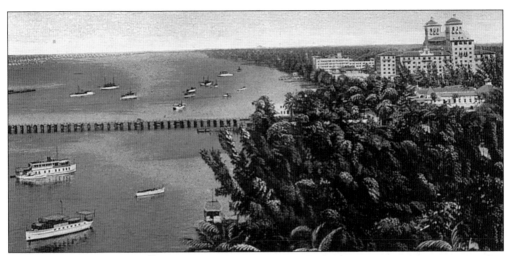

Maurice Heckscher, a New Yorker and winter resident, took over the project and re-named it the Alba Hotel, to honor of Spain's Duke of Alba, a polo-playing crony. Heckscher built the Alba in 1926 at a cost of $9 million. The duke was slated to be the guest of honor at the grand opening ceremonies, but because of illness, he was a no-show.

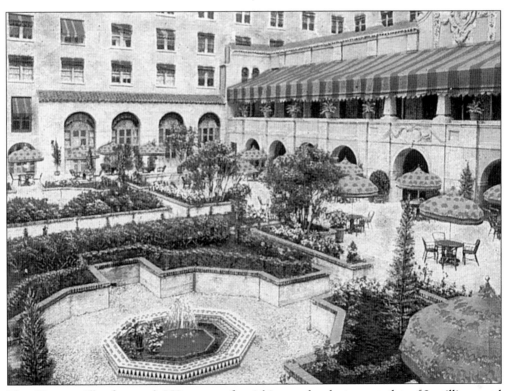

The 12-story Alba featured 550 rooms, furnishings valued at more than $2 million, and beautiful formal gardens matching the hotel's Spanish motif. From the opening night's festivities, which the house staff threatened to walk out on, the Alba seemed doomed. Fewer than two months after its festive opening, the hotel was awash in red ink and later closed.

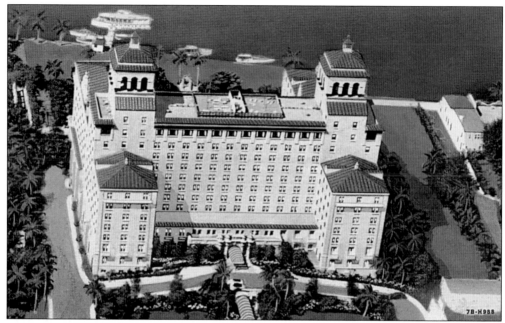

The Alba was later re-opened as the Ambassador in 1929 and, in 1931, as the Biltmore. During World War II, it served as a women's Coast Guard training center and, after that, as a U.S. Navy convalescent hospital.

The Brazilian Court Hotel, which opened January 1, 1926, was designed by New York architect Rosario Candela. Maurice Fatio designed later additions to the building. Built with 116 units around an inner courtyard, the hotel provides coziness and seclusion and exudes old-world charm. It has served as the Palm Beach home of many celebrities, including Helen Keller, Gary Cooper, Cary Grant, and Richard Nixon.

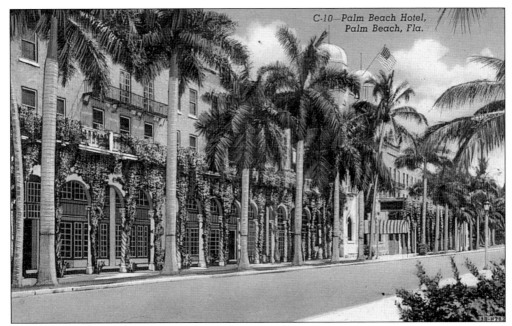

The Palm Beach Hotel, located at 235 Sunrise Avenue, opened in 1925. It was designed by Mortimer Metcalfe, who also drew the plans for St. Edward's Church and other Palm Beach buildings.

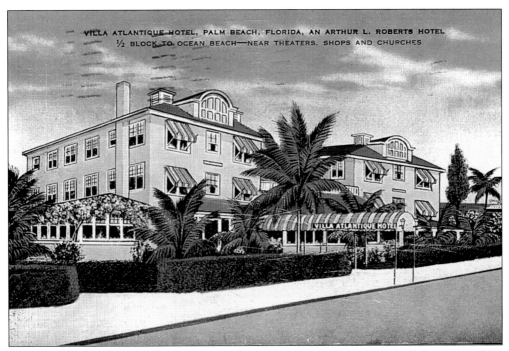

Winter residents often checked into one of the island's hotels, such as the Atlantique, while their servants opened up their villas and prepared them.

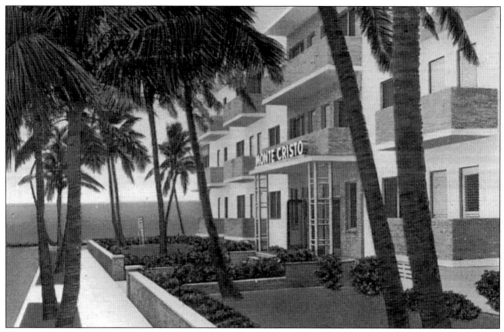

Though it was not a large hotel, the Monte Cristo was like many Palm Beach hotels in offering its guests a wide variety of amenities, such as a swimming pool, solarium, health club, coffee shop and cocktail lounge, game room, and cabana service on the beach nearby.

The Ocean View Hotel had a prime location along Worth Avenue in the heart of the shopping district. It billed itself as a place "for fastidious folks who wish both refinement and moderate rates."

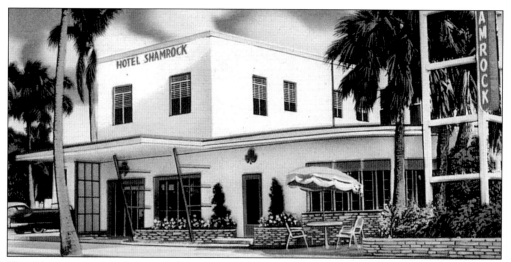

The 50-room Hotel Shamrock boasted that its location put it close to both the beach and shopping areas. Its design would have made it a comfortable fit in Florida resort communities down the state's east or west coast.

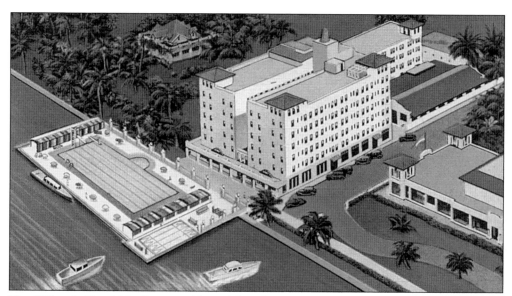

The 250-unit Hotel Mayflower, with its lakeside view, gave guests a beach-like experience with a cabana club and pool.

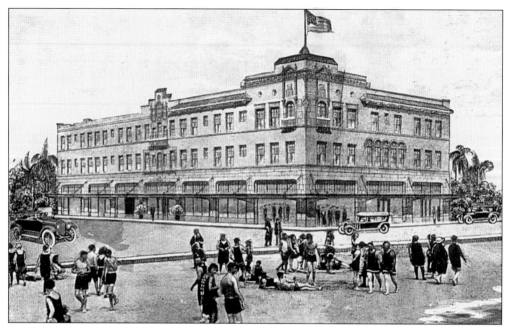

Summer always was in full swing at the Hotel Billows, which catered to visitors of more modest means. The three-story hotel was open year-round.

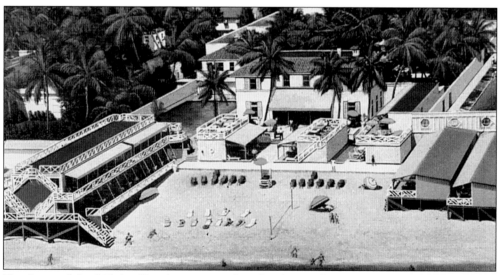

The Sun and Surf Club offered a spacious beach, plenty of cabanas, and a swimming pool for days when the ocean was less than accommodating.

Some winter residents treated their hard-working, faithful staffers especially well by checking them into smaller, more modest accommodations, such as the Seaglade Hotel, which features red barrel tile, patios, and fountains in the same style as the larger hotels but built to a smaller scale.

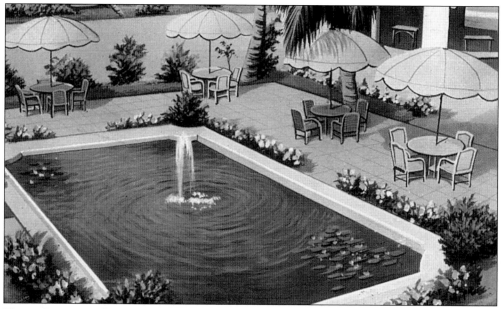

Their generosity allowed the winter residents' staff the chance to spend their days off living the good life and paid their employers other dividends—increased employee loyalty.

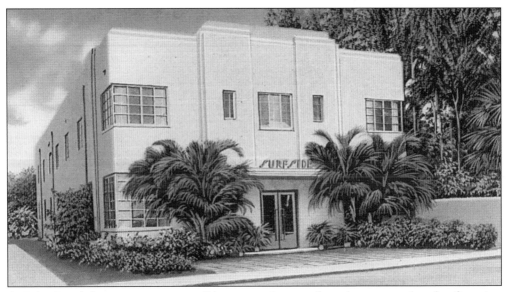

As Palm Beach became more accessible to vacationers of varying means, hotels of varying sizes became available. The Surfside showed architectural elements common to the Art Deco era.

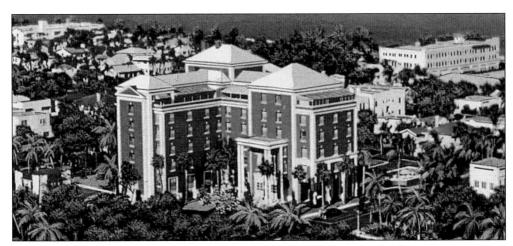

The Colony Hotel, with 100 units, is centrally located a block south of Worth Avenue and a block from the ocean. The six-story hotel offers a grand view of Lake Worth, the Atlantic, and the city.

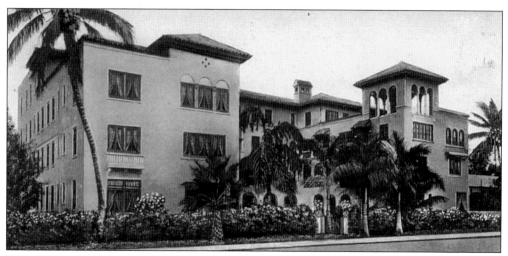

Palm Beach Plaza, located at Sunset Avenue and Bradley Place and designed by Martin Luther Hampton, was a hybrid edifice, offering a mixed residential and commercial property growing from around a central courtyard.

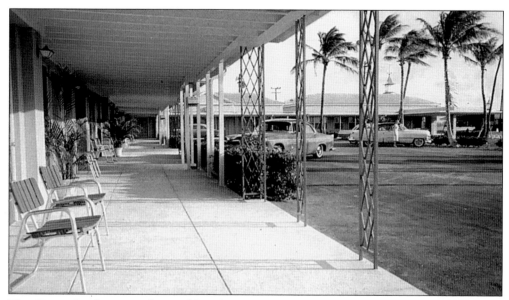

The Howard Johnson's chain of hotels and restaurants was among the first to cater to working-class Americans who preferred to travel by car.

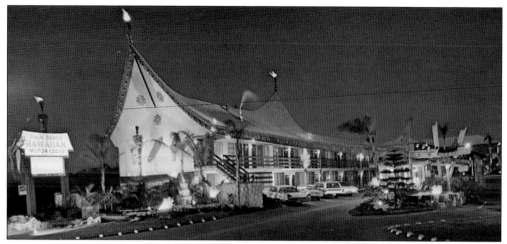

The Palm Beach Hawaiian Motor Lodge brought a touch of the Pacific to Palm Beach.

The El Seville Hotel, located at 214 Chilean Avenue, was cozy, yet open, and constructed around a central courtyard.

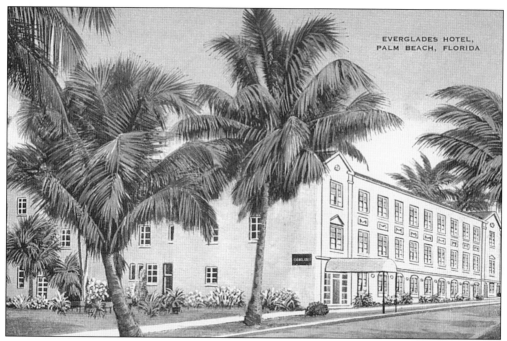

Eventually, accommodations in all price ranges became plentiful. Other hotels on the island included the Everglades (shown above), Ardma, Sea Lord, Ocean Echo, Hotel Testa, the Heart of Palm Beach, and even the Whitehall Hotel, constructed from the converted mansion after Mary Lily Flagler's death in 1917. The 12-story hotel addition behind Flagler's mansion was razed in 1959. Flagler's granddaughter re-opened Whitehall as the Henry Morrison Flagler Museum in 1960.

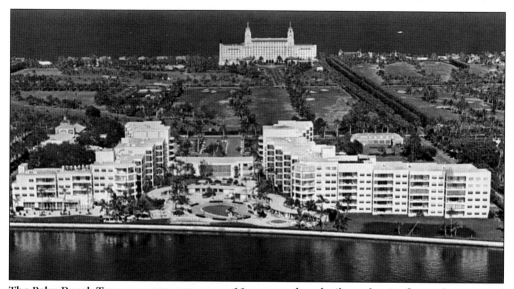

The Palm Beach Towers apartments cover 11 acres and are built on the site formerly occupied by the Royal Poinciana Hotel.

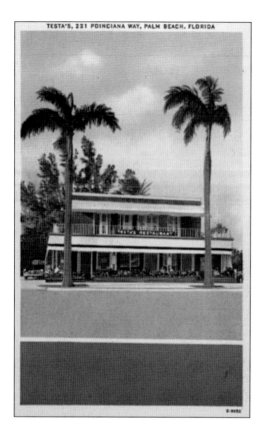

TESTA'S, 221 POINCIANA WAY, PALM BEACH, FLORIDA

Testa's Restaurant is the island's oldest eatery, serving steaks, seafood, and Italian specialties since 1921. The restaurant is still among Palm Beach's favorite winter dining spots, and the tables along the front, next to the sidewalk, are one of the best spots on Royal Poinciana Way for people-watching.

Maurice's Restaurant, which opened in 1944 across from the Biltmore, also specialized in steaks, seafood, and Italian cuisine. The Vesuvio Lounge there provided cold libations, soft lighting, and intimate talk.

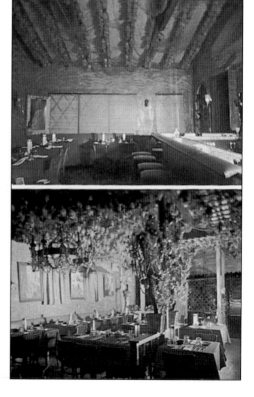

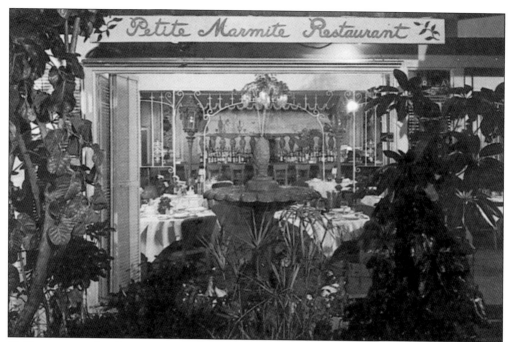

Unlike many of Palm Beach's high-end restaurants, Petite Marmite served luncheons, cocktails, and dinners year-round. It was opened in November 1949 by Costanzo "Gus" Pucillo and his wife, the former Geraldine Jameson.

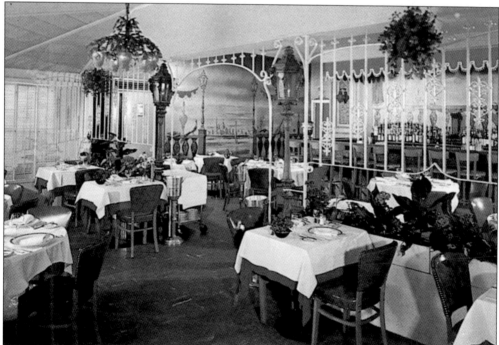

The Pucillos had come to South Florida to visit Gus Pucillo's sister, who lived in Lake Worth and, upon visiting Palm Beach, found a Worth Avenue site where they could establish a unique restaurant featuring Continental specialties.

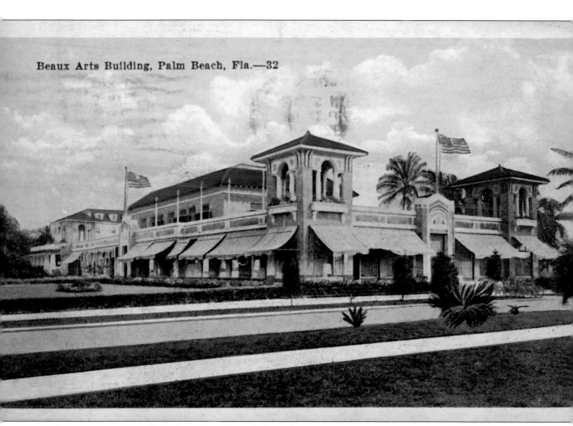

Beaux Arts Building, Palm Beach, Fla.—32

The construction of Flagler's hotels and the others that followed helped create an atmosphere of competitive consumerism that exists today. Island merchants help whet the expensive tastes of residents and visitors alike with fashions, jewelry, and other top-drawer consumer goods from all corners of the globe. The Beaux Arts Building on Lake Trail, pictured on the card, was one of the first shopping centers on the island.

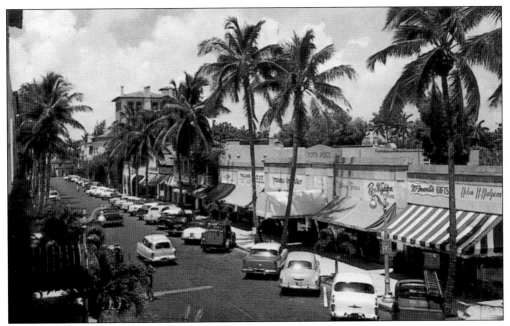

Worth Avenue, which starts at the beach and goes west past the Everglades Club and Casa dei Leoni, has become one of the world's great shopping streets.

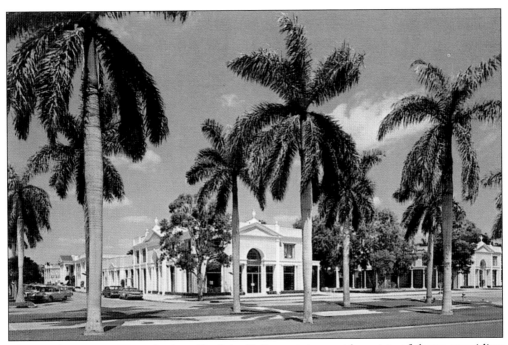

The Royal Poinciana Plaza, designed by John Volk, contains a wide variety of shops, providing items from fresh flowers and sundries to clothing, jewelry, and high-end gifts.

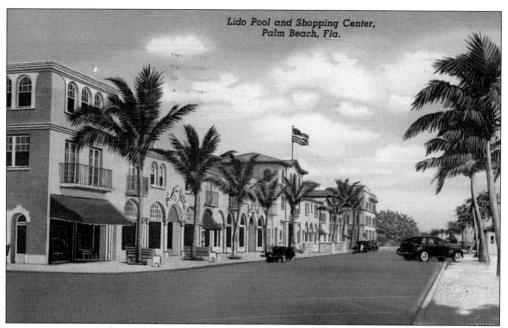

Palm Beach shops traditionally offer outstanding goods from around the world. With so many beautiful goods, usually displayed in ornate and imaginative window displays, browsing is almost as fun as buying.

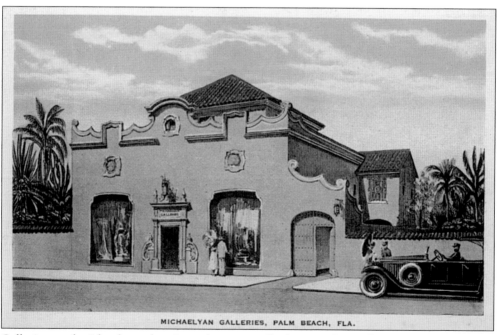

Galleries on the island—and antique shops as well—have traditionally done brisk business, selling to a knowledgeable, savvy clientele. Many of them also had offices in New York, London, or elsewhere.

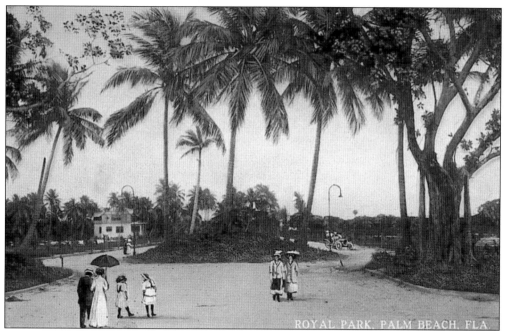

More affordable—but by no means cheap—housing gradually became more readily available. One such development was Royal Park, the first significant housing development after the Flagler heydays.

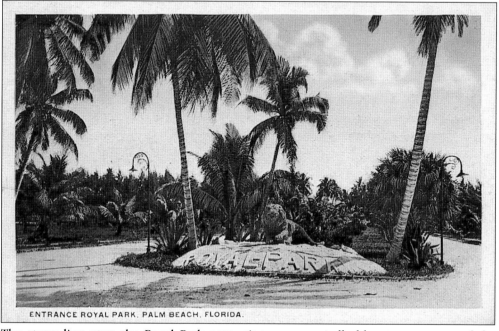

ENTRANCE ROYAL PARK, PALM BEACH, FLORIDA.

The stone lion atop the Royal Park entry sign was reputedly blown up as a prank by Horace Chase, the son of banker Horace Blanchard Chase and Ysabel Mizner Chase, Addison Mizner's sister.

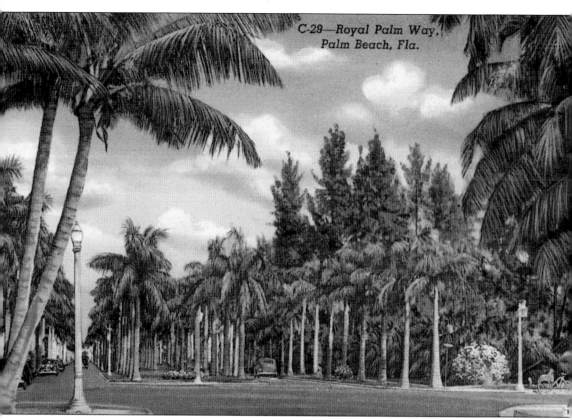

C-29—Royal Palm Way, Palm Beach, Fla.

Royal Palm Way was created as the main east-west thoroughfare from the Lake Worth bridge to the ocean through Royal Park. From west to east, it intersects with Lake Drive, Cocoanut Row, Hibiscus Avenue, South County Road, and finally at South Ocean Boulevard.

Six

FUN AND GAMES

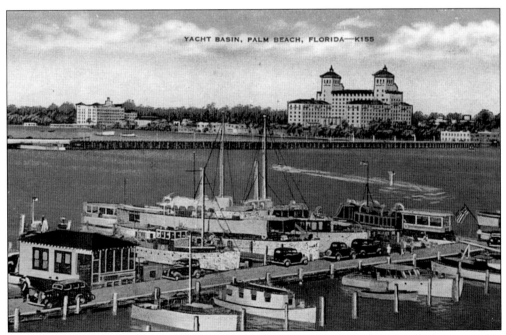

YACHT BASIN, PALM BEACH, FLORIDA—K155

The wealthy folks who flocked to Palm Beach found it a perfect place to ply their sporting passions. There, they could play year-round. Watersports and fishing in fresh, salt, and brackish water were all world-class. The yacht *Orca*—a favorite of presidents, Ned Stotesbury's yacht *Nedeva,* and Charles J. Clarke's yacht *Alma* were among those that tied up at the town's marina and yacht basin during the season.

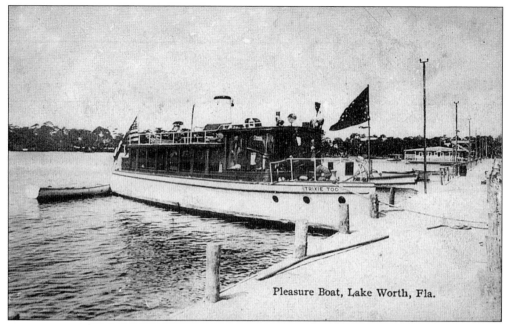

Pleasure Boat, Lake Worth, Fla.

For those who didn't own a yacht, pleasure boats were abundant and available for hire for those who wished to cruise Lake Worth and the Intracoastal Waterway.

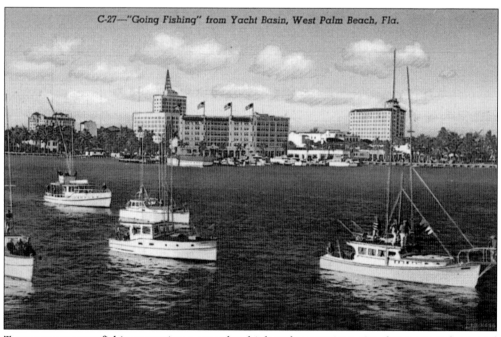

C-27—"Going Fishing" from Yacht Basin, West Palm Beach, Fla.

Tournament sportfishing remains a popular, high-stakes pastime. On this postcard, several West Palm Beach landmarks are visible. Above the lead boat is the Dixie Court Hotel. The building with the antenna on top is the Harvey Building.

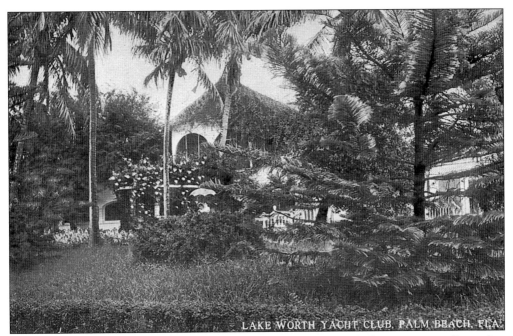

Several organizations, such as the Lake Worth Yacht Club, provided regattas as well as other activities and competitions for the nautical set. They also functioned as social clubs. Boat owners commonly had repairs, refinishing and other alterations, and routine maintenance done to their boats while in South Florida. As a partial result, southeastern Florida's marine industries are among the world's most diversified and best.

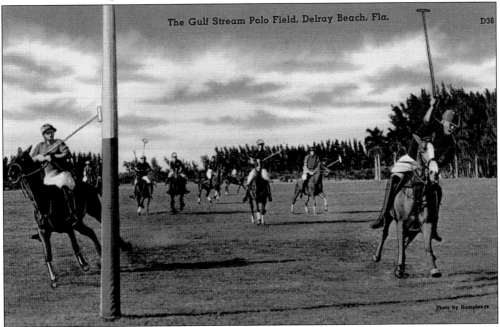

The Gulf Stream club became a center for wintertime polo action. Each year, from December through April, the best polo players in the world still come to Palm Beach County to play "the sport of kings" at clubs from Boca Raton to Wellington.

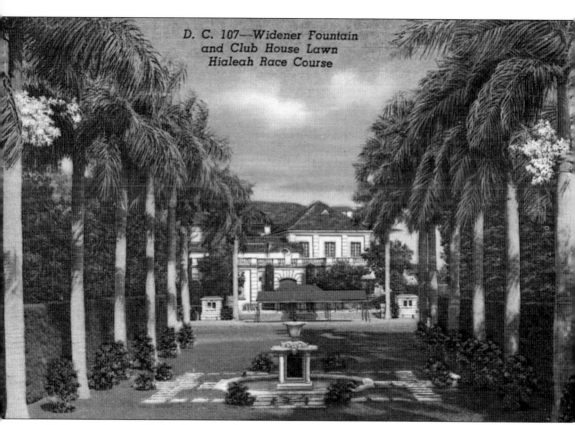

D. C. 107—Widener Fountain
and Club House Lawn
Hialeah Race Course

Pari-mutuels provided enjoyment for many Palm Beachers. Flagler built a spur line of his railroad from Palm Beach to Hialeah for thoroughbred racing. Joe Widener, Hialeah's owner, lived on Palm Beach at Il Palmetto, designed by Maurice Fatio. Mizner disciple Lester Geisler designed the Hialeah Park, whose symbol has long been the flamingo, but when Flagler's railroad dropped his wealthy, well-dressed guests off at the gate, the pathway they took to the clubhouse became known as Peacock Alley.

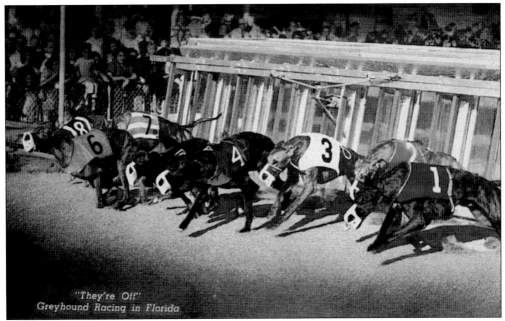

"They're Off"
Greyhound Racing in Florida

Greyhound racing and the Basque game of jai-alai later became available in nearby West Palm Beach. Another spectator sport of importance was baseball. Teams of workers from Flagler's hotels played on diamonds near the Royal Poinciana. Hotel guests often sat in the bleachers and enjoyed the game. Boxing, croquet, and polo also were popular on the island.

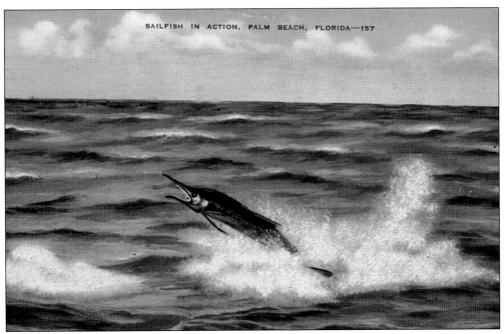

SAILFISH IN ACTION, PALM BEACH, FLORIDA—157

The waters off Palm Beach are superb for sports fishermen. Sailfish season is at its height in December. The best month for white marlin is January, and blue marlin are at their peak in March through July.

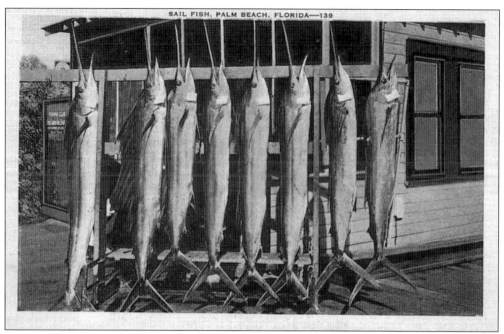

Other prized saltwater sport fish that have lured anglers to Palm Beach for decades include dolphin, cobia, bluefish, and king mackerel. Grouper are often taken in deeper waters.

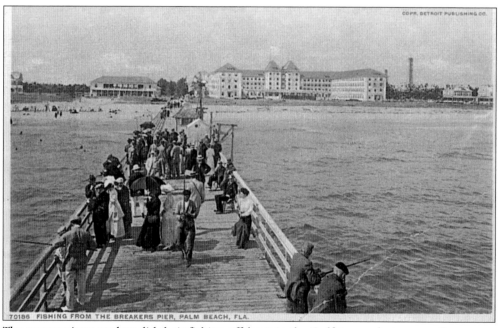

The most serious anglers did their fishing offshore in the Gulfstream, but many others were content trying their luck from one of the piers, trying to hook a yellowtail or pompano.

Fishing on the Banks of the River In Florida.

One of the amusements of PALM BEACH, FLA. It's grand here

Still other fishermen were content with finding a quiet spot and wetting a line on the banks of a canal, where a variety of species, including alligator, gar, bass, bluegill, catfish, crappie, oscars, shellcrackers, tilapia, and warmouth were available.

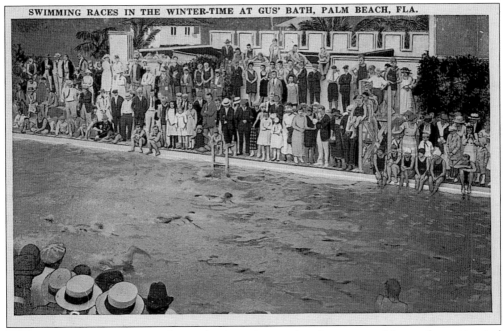

SWIMMING RACES IN THE WINTER-TIME AT GUS' BATH, PALM BEACH, FLA.

Swimming pools were popular and wintertime swimming competitions often attracted world-champion caliber swimmers to the area.

The Atlantic Ocean was—and still is—the object of many visitors' recreational attention, from fishing, swimming, and diving back in Flagler's day to newer pursuits such as parasailing, scuba diving, and motoring around in personal watercraft.

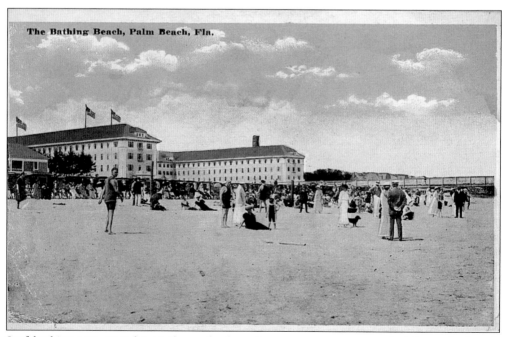

Surf bathing was popular in the early days. Long ropes were extended from the beach to buoys offshore so bathers could venture out into the surf without fear of being swept away and drowning.

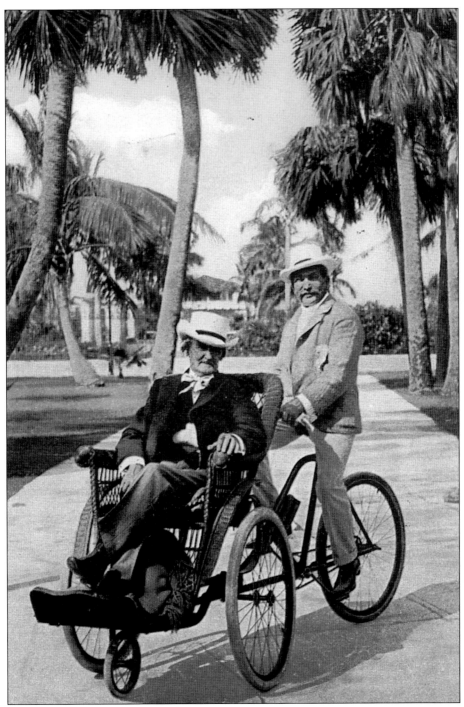

Perhaps the most unique and enjoyable form of recreation enjoyed by visitors was touring the island on bicycle carriages called afromobiles. Actor Joseph Jefferson, well known for his masterful performances as Rip Van Winkle, is shown here with his driver. Jefferson, who lived in Palm Beach, invested heavily in Palm Beach County, including the county's first electric plant and a variety of residential properties.

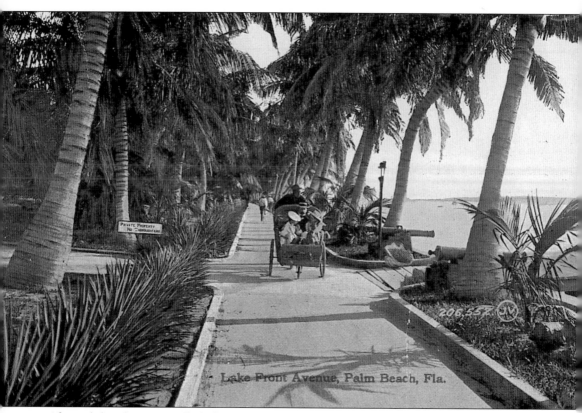

Lake Front Avenue, Palm Beach, Fla.

Afromobiles also were called afrimobiles and aframobiles. Early models were designed with the driver in the front, but later models placed the driver in back, so as not to interrupt the rider's view. The earliest models were made for single riders only. Later models were spacious enough for two. The afromobiles and the mule line were the only forms of public transportation Flagler permitted on his island properties.

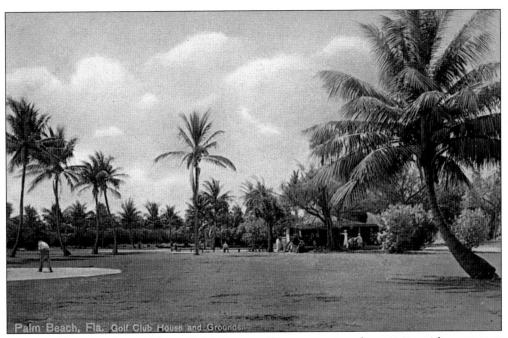

With excellent weather and beautiful foliage, golf became a popular activity, with courses at the Royal Poinciana, the Breakers, Everglades Club, and elsewhere.

Southeastern Florida's golf courses often proved exceptionally challenging to northern golfers because the soft, sandy ground yields a more modest bounce and "carry."

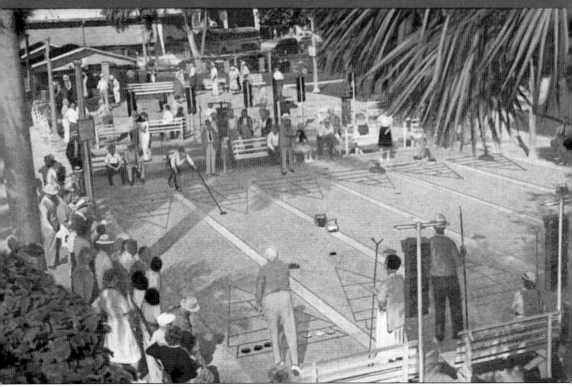

Shuffleboard enjoyed its heydays in the 1950s and is a popular game among senior citizens living in South Florida. The game involves sliding hard plastic disks at numbered spaces. The object is to slide your disks into the numbered space and to knock your opponent's disk out of them, while avoiding the dreaded "10 off" spaces. Most South Florida resorts offer a court or two, as well. The game offers some stretching, a little physical activity, and the chance for socializing.

Seven

THE GARDEN OF EARTHLY DELIGHTS

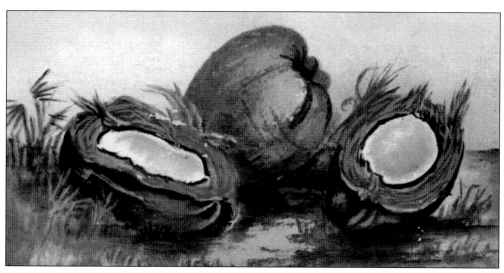

Florida, meaning "Land of Flowers," was the name given by the Spanish explorers when they arrived, and southern Florida's foliage is particularly abundant. From its soil and warm climate come a variety of fruits that are as pleasing to the palate as they are to the eye. Henry Flagler used to bring a bagged lunch to work each day but insisted to the chefs at his resorts that they offer their guests a variety of the tropical fruits that grow in southeastern Florida. The Seminoles grew berries that they sold to settlers and visitors. Bananas grew abundantly on the island and pineapples also were well-suited, but Flagler's chefs and gardeners brought far more to the tables. The wreck of the *Providencia* in 1878 forever linked Palm Beach with the coconut (*Cocos nucifera*). Throughout the island's heydays, coconut cake was a staple on dessert trays throughout the island and other coconut confections were well loved.

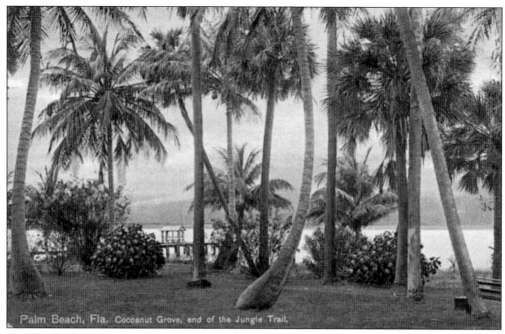

Palm Beach, Fla. Cocoanut Grove, end of the Jungle Trail.

Gus Ganford, a winter visitor from Philadelphia, is credited with suggesting the name "Palm Beach," from the Jamaica Tall variety of coconuts that the *Providencia* carried in her hold when she ran aground.

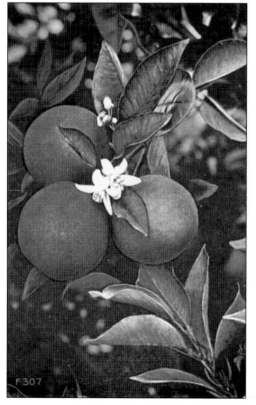

Although the Palm Beaches were not as well known as Central Florida or the Indian River region for citrus, oranges, tangerines, kumquats, grapefruits, and other citrus, fruits grow abundantly in the area. Some Palm Beach estate owners maintained small groves on their property. The delicate orange blossom is Florida's state flower.

A native of India, the mango (*Mangifera indica*) was successfully introduced to southeastern Florida in 1861 and became popular immediately. Its sweet taste carries a hint of pineapple and peach flavors but is unique and delicious. Dr. Elbridge Gale, a Kansas State agricultural professor, retired to Florida in 1884 and introduced the mango to the Palm Beaches. His former student, David Fairchild, brought him some small Mulgoba trees from India. From Fairchild's trees came the first Haden mangoes, named in honor of Capt. John Haden of Miami. Gale's daughter Hattie served as Dade County's first schoolteacher in 1886. The original one-room schoolhouse is still in Palm Beach at Phipps Ocean Park.

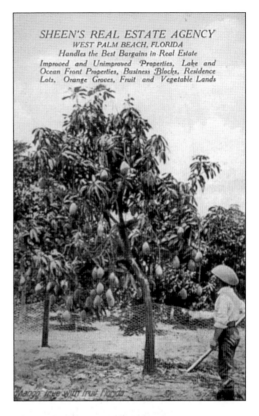

SHEEN'S REAL ESTATE AGENCY
WEST PALM BEACH, FLORIDA
Handles the Best Bargains in Real Estate
Improved and Unimproved Properties, Lake and Ocean Front Properties, Business Blocks, Residence Lots, Orange Groves, Fruit and Vegetable Lands

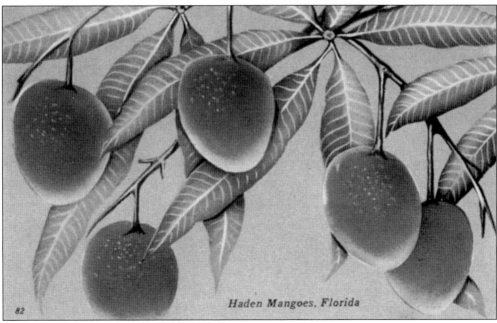

Haden Mangoes, Florida

The Haden mango went on to become the first commercially successful mango cultivar. Mango trees still grow abundantly in West Palm Beach's Northwood Hills neighborhood, which Gale called Mangonia. Palm Beach County also has a municipality named Mangonia Park.

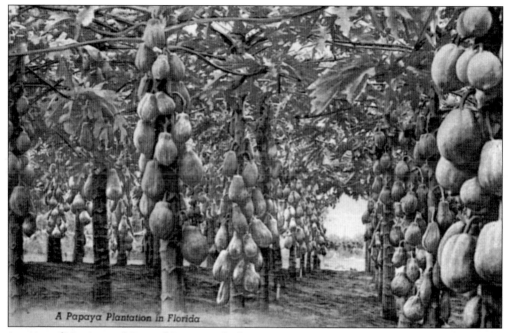

A Papaya Plantation in Florida

A native of Mexico and Central America, the hearty papaya (*Papaya carica*) grows particularly quickly, and its tangy taste quickly became a favorite among winter visitors to Palm Beach.

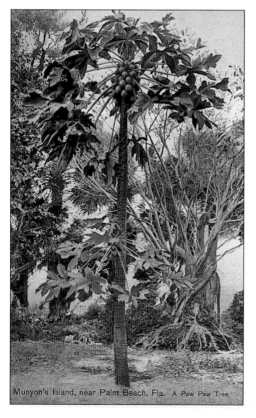

Munyon's Island, near Palm Beach, Fla. A Paw Paw Tree.

Papaya juice was the special ingredient in Dr. John Munyon's patent medicine that he created and sold on the 22-acre island bearing his name in the Lake Worth lagoon east of Riviera Beach. The elixir was a mix of "pawpaw" juice, water, and a heady dose of alcohol. Munyon Island also contained his extensive tropical gardens and a small hotel. Ferries connected it with Palm Beach and the mainland.

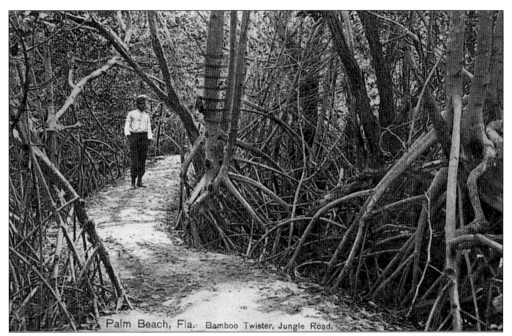

Though the postcard indicates the trees are bamboo, they actually are mangroves (*Rhizophora mucroniata*), which grow at the shoreline in brackish water and are essential to maintaining South Florida's delicate ecosystem.

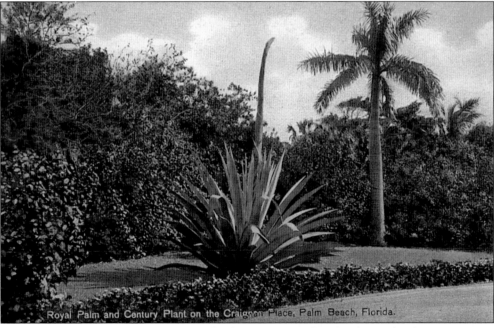

Coconut palms were only one variety of palms grown on the island. Royal palms (*Roystonea regia*), with their gray ramrod-straight trunks that almost seem to be made of cast cement, also are popular. Shown to the left of the royal palm is a century plant (*Agave americana*), named for the erroneous belief that the plant flowered once every hundred years.

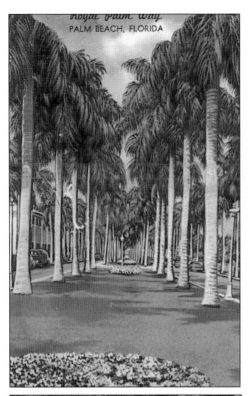

In the Jungle, Palm Beach, Florida.

Above Left: Royal palms were introduced to the island by Elisha Dimick in the 1880s. Dimick, who purchased hundreds of coconuts from the *Providencia* to plant, also introduced kapok trees to the island from the Bahamas.

Above Right: Sugar cane is grown on the southern shore of Lake Okeechobee, and two cities especially associated with cane-growing—Belle Glade and Pahokee—are in Palm Beach County, 60 miles west of Palm Beach. Though sugar cane was grown in Palm Beach County earlier, it was introduced as a major commercial crop in 1931.

Left: The jungle trails on the island offered some outstanding botanical specimens. The trees arching over the path here are gumbo limbo trees (*Bursera simaruba*), native to the Amazon region, Central America and Haiti.

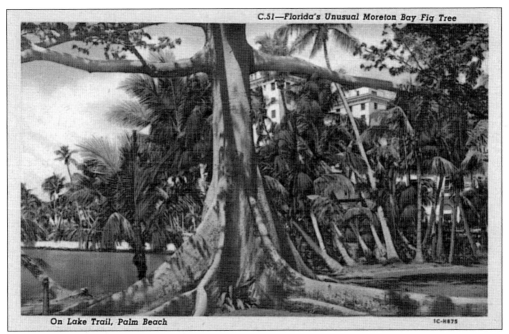

C.51—Florida's Unusual Moreton Bay Fig Tree

On Lake Trail, Palm Beach

Trees from the ficus family seem to thrive particularly well in southern Florida. The Moreton Bay fig (*Ficus macrophylla*), native to Australia and commonly grown in Southern California, is less commonly seen in Southeastern Florida than other varieties.

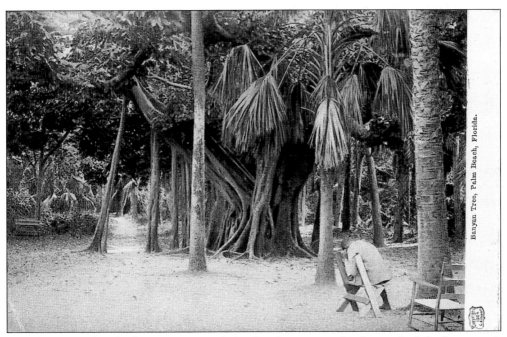

Banyan Tree, Palm Beach, Florida.

The dramatic Florida fig (*Ficus aurea*) is also known as the "strangler" fig because it sometimes engulfs and overcomes other trees around it.

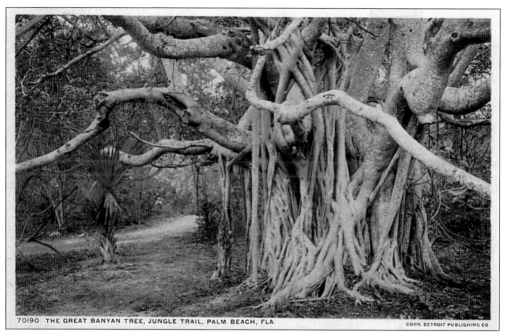

70190 THE GREAT BANYAN TREE, JUNGLE TRAIL, PALM BEACH, FLA. COPR. DETROIT PUBLISHING CO.

The banyan tree (*Ficus benghalenis*) is native to India, where vendors set up their stands to conduct business under the tree's abundant shade.

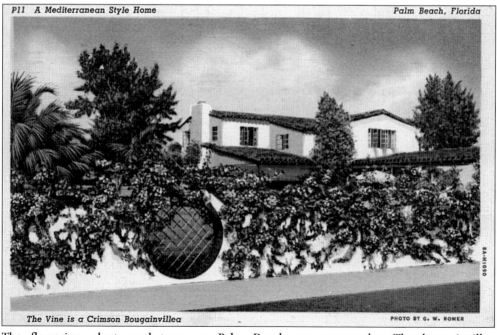

P11 A Mediterranean Style Home Palm Beach, Florida

The Vine is a Crimson Bougainvillea PHOTO BY G. W. ROMER

The flowering plants and trees on Palm Beach are spectacular. The bougainvillea (*Bougainvillea glabra* and *B. spectabilis*), native to Brazil, grow quickly into thorny, dense crawling vines.

An Arbor of Purple Bougainvillea in Florida

The bougainvillea flower has a tiny white blossom at its center and is surrounded by three colorful, papery panels that range in hue from a deep purple to crimson, salmon, pink, butterscotch, pale yellow, and white.

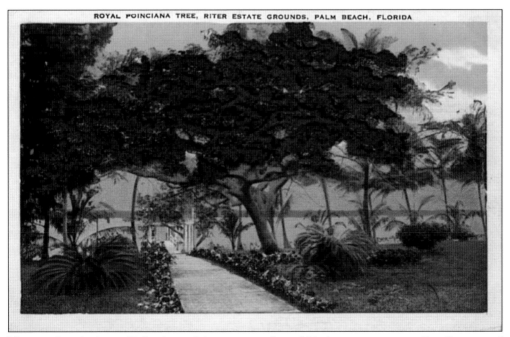

ROYAL POINCIANA TREE, RITER ESTATE GROUNDS, PALM BEACH, FLORIDA

The royal poinciana (*Delonix regia*) tree, a native of Madagascar, comes alive for several weeks each spring with dramatic yellow-orange flowers that seem to engulf the entire tree.

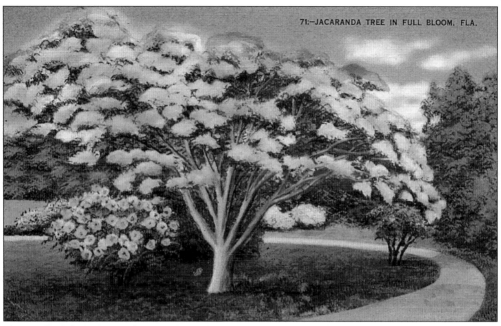

Also colorful and popular on the island is the jacaranda tree (*Jacaranda mimosifolia*). Native to Brazil and Argentina, the jacaranda blooms in late spring, bearing huge clusters of lavender or white blossoms.

The palmetto plant (*Serenoa repens*), shown as younger trees on this postcard, proved a problem to developers, who found it difficult to uproot the plant's many wire-like roots. The very young plant's berries are sought for homeopathic compounds for male urinary problems.

The heart of the palmetto, the area at the base of the fronds, makes an excellent salad with a crunchy, nutty taste, a delicacy that remains popular with tourists. Unfortunately, to obtain the heart of the palmetto, the remainder of the tree must be destroyed.

Palm Walk, Palm Beach, Fla.

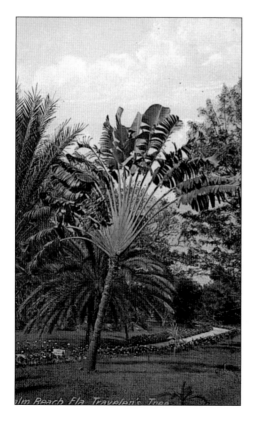

The traveler's tree (*Ravenala madagascariensis*), a native of Madagascar, is one of the most dramatic ornamental trees seen on Palm Beach. Its name came about because thirsty travelers can pull down a frond and get a drink of water.

97

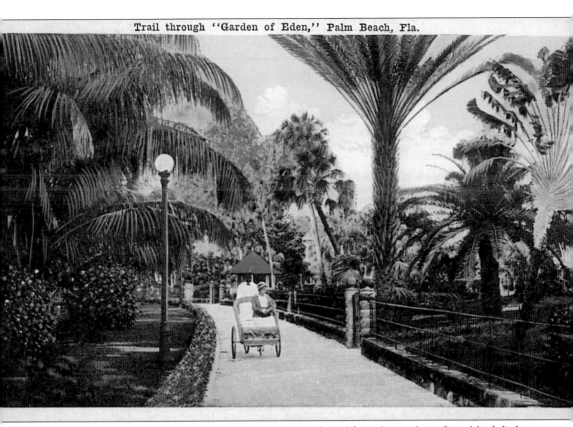

While many visitors to Palm Beach wrote home that they'd found a garden of earthly delights, the Charles I. Cragin family of Philadelphia, longtime residents of Palm Beach, went a step further. They landscaped their two-story home into a sea-to-lake botanical park they named the Garden of Eden, which demonstrated the incredible range of plant life that could be grown on the island.

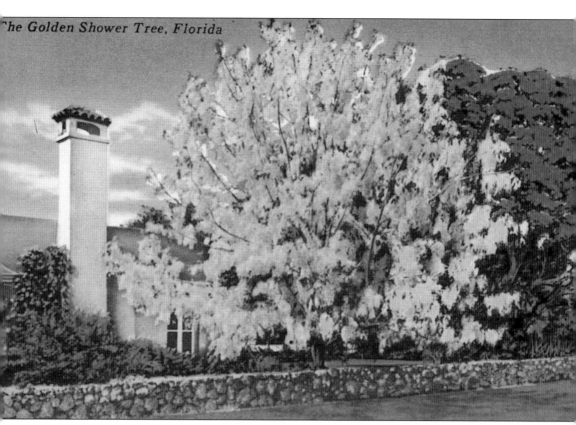

The Golden Shower Tree, Florida

The Cragin family filled their garden with every plant variety that grew on the island,; they also introduced a few there. One of the focal points of the Garden of Eden was the island's only Golden Shower tree (*Cassia fistula*), actually a legume that can grow to 40 feet. In other countries, its seeds are used for a variety of medicinal purposes, from curing eczema to relieving constipation.

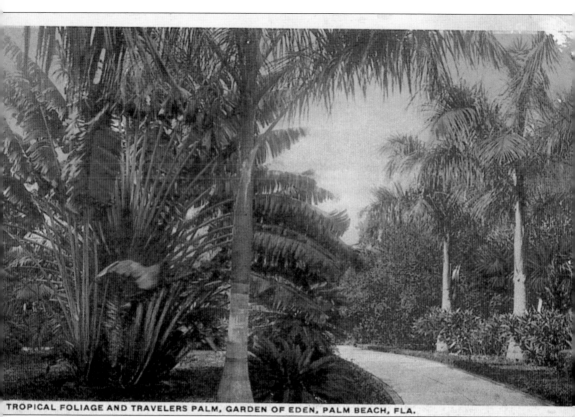

TROPICAL FOLIAGE AND TRAVELERS PALM, GARDEN OF EDEN, PALM BEACH, FLA.

A variety of ornamentals were planted in the Garden of Eden, such as crotons (*Codiaeum varigaturn*), with their vivid, multicolored leaves, which range from a wide variety of reds to orange, yellow, and green. The crotons appear on the card as bushes at the right side, in front of the two young royal palms. Though lovely to look at, crotons are toxic. Sap from the leaves and stem leaves a permanent brown stain on fabrics and is difficult to wash from the hands.

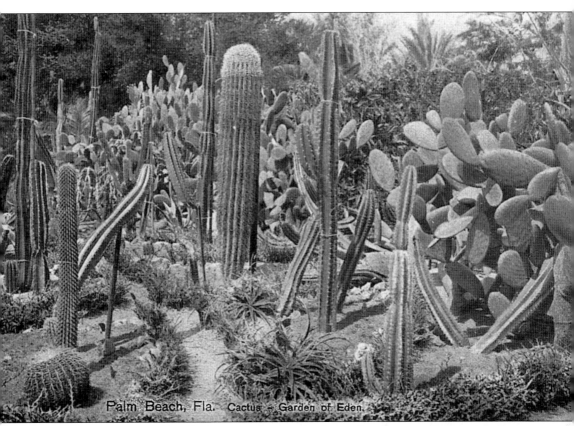

Palm Beach, Fla. Cactus – Garden of Eden.

Many visitors to the Garden of Eden were surprised to learn that cactus and other succulents usually associated with dry climates, such as the American Southwest, also were able to flourish in South Florida's sandy soil and humidity. In addition to prickly pears and other varieties of cactus, air plants, and bromeliads also thrive in southeastern Florida.

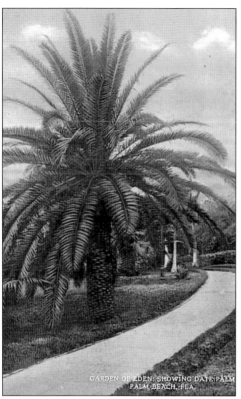

The trail leading through the Garden of Eden was ringed with a variety of tropical trees, including the date palm (*Phoenix dactylifera*), a native of Israel and the Middle East.

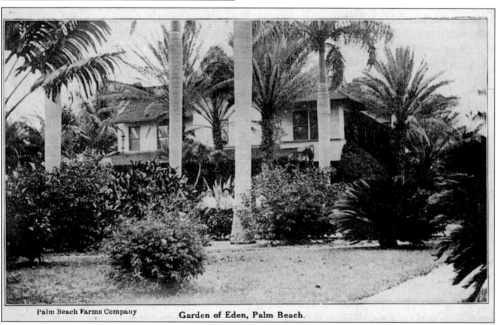

Palm Beach Farms Company Garden of Eden, Palm Beach.

The Palm Beach Farms Company used this scene from the Garden of Eden to sell property. On the reverse of the card, it notes: "Five acres enough? Yes, in Palm Beach County, Florida, 'the garden spot of the world.' Set aside 34 cents a day and own a beautiful semi-tropical home."

Eight

EDUCATION
AND RELIGION

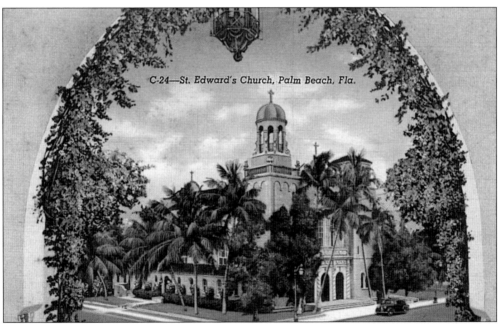

C-24—St. Edward's Church, Palm Beach, Fla.

Though Palm Beach was developed as a resort and contains all the amenities necessary for world-class vacationing, the island also is home to many year-round and seasonal residents, who have other needs. Among those needs are schools for their children and grandchildren and houses of worship. The island has but a few schools, churches, and synagogues, but they all are interesting and historic. The island's Catholic church, St. Edward's, is the church the Kennedy family attended when Palm Beach served as the "Winter White House." It is located on North County Road and one of its biggest benefactors was Col. Edward R. Bradley, the casino owner, who donated the property on which the church was built.

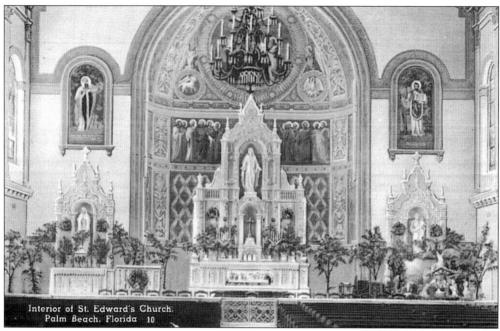

St. Edward's Church was designed by Mortimer Metcalfe and constructed in 1926–1927. All of the altars and statues were made of Carrara marble in Italy and shipped to Palm Beach.

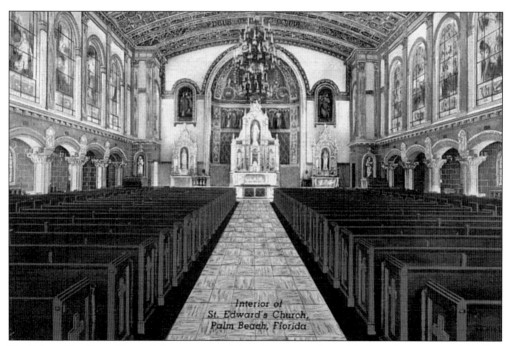

St. Edward's Church's architecture combines Baroque, Spanish Renaissance, and Italian elements to provide a beautiful, solemn effect. It continues to serve the needs of Palm Beach's Roman Catholic residents and visitors.

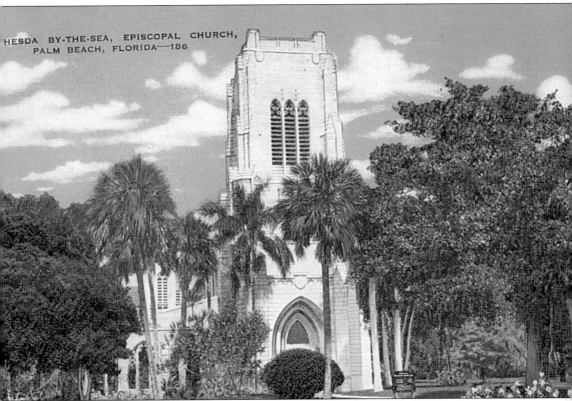

The spiritual home of many Palm Beachers and visitors is Bethesda-by-the-Sea Episcopal Church, centrally located on the island at 141 South County Road, at the intersection with Barton Road. The 15th-century Gothic Revival design of the church was created by the architectural firm of Hiss and Weeks and built in 1927. The dramatic stained-glass windows within were designed and assembled in England and shipped to the United States.

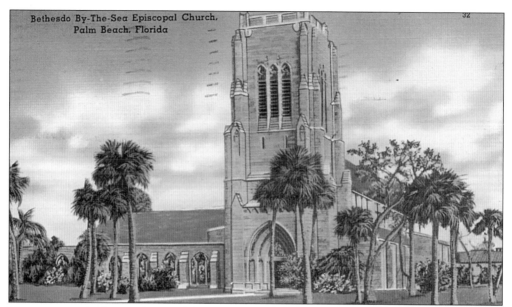

Bethesdo By-The-Sea Episcopal Church, Palm Beach, Florida

The rectory, which was designed by Marion Wyeth, was built in 1924 and is shown at the right of the card. Wyeth also designed later additions to the church. Note the spelling of the church's name on the card.

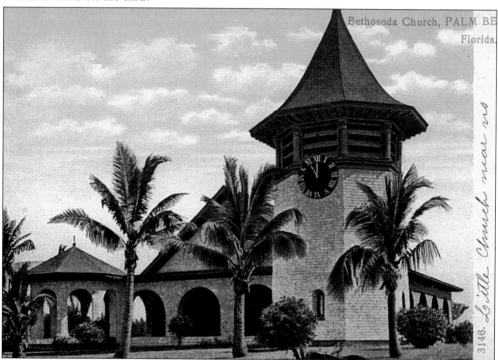

Bethosoda Church, PALM BE Florida.

3146. Little Church near us

The current Bethesda-by-the-Sea is the third church bearing the name. The first was a small wooden building on North Lake Trail constructed partially of lumber that had been washed ashore. The church shown here was the second Bethesda-by-the-Sea, located on North Lake Way. It was of Moorish design, built in 1894, and consecrated in 1895. Last used as a church in April 1925, the building is now a private residence. Note the spelling of the name.

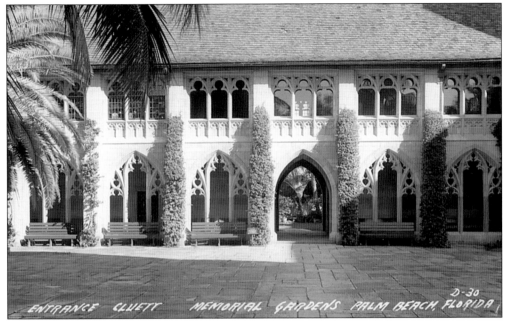

This is the northern wing of the church that contains offices and a gift shop and serves as the entryway to the Cluett Memorial Gardens. Adjacent to it on the east is the columbarium, where the ashes of many Palm Beachers are interred, including architect John Volk.

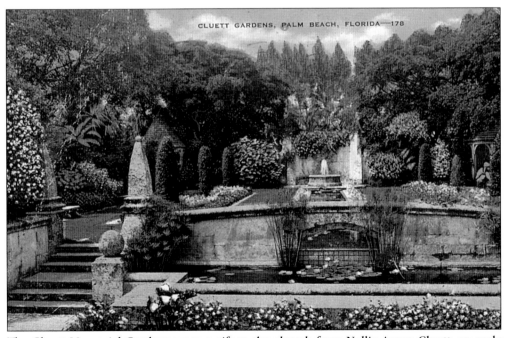

The Cluett Memorial Gardens were a gift to the church from Nellie Agnes Cluett, an early resident of Palm Beach, who made the gift in 1931 as a tribute to her parents, George Bywater Cluett and Amanda Rockwell Cluett.

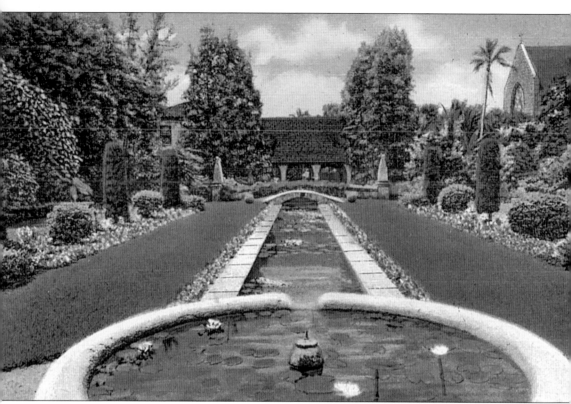

A formal garden with a reflecting pool, small waterfall, and fountain, the Cluett Memorial Garden is a perfect place for prayer, meditation, or a moment's peace and reflection. The garden contains a variety of botanical specimens, among them the delicate blue-blossomed Cape plumbago (*Plumbago auriculata*), the weeping bottle brush (*Callistemon viminalis*), Natal plum (*Carissa macrocarpa*), Crown of Thorns (*Euphorbia milii*) and papyrus (*Cyperus papyrus*). Mary Cluett Mulford, the wife of the church's first vicar, Joseph Mulford, gave the church its name and started its first women's club. Another family member, Sanford Cluett, who began visiting Palm Beach during his childhood, went on to become an inventor. Among his innovations were a sextant for celestial navigation and the process known as "Sanforizing."

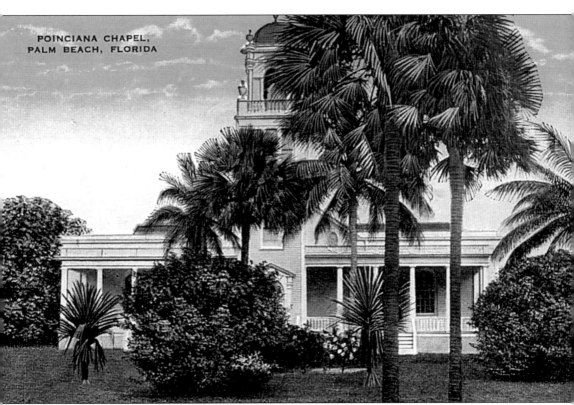

POINCIANA CHAPEL,
PALM BEACH, FLORIDA

The Royal Poinciana Chapel, also known as The Little White Chapel, was an interdenominational church built during 1897–1898 for guests at Flagler's hotels. Flagler handled many of the details surrounding the church himself, including the selection of its pastor. The church has a capacity of just over 900 worshippers inside and just over 200 on the porch outside. Before the Royal Poinciana chapel came into existence, ecumenical religious services were held in the island's one-room schoolhouse built in 1886.

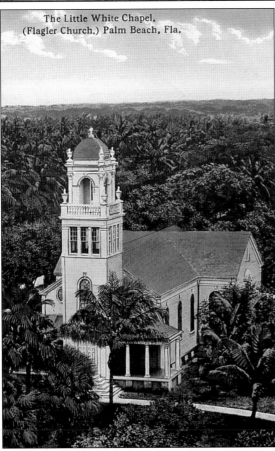

The Little White Chapel,
(Flagler Church,) Palm Beach, Fla.

The Royal Poinciana Chapel was originally built next to Whitehall, south of the Royal Poinciana Hotel, but in 1972, it was moved to its current location on Cocoanut Row.

Flagler hired Rev. George Morgan Ward, who had been named president of Rollins College in Winter Park in 1896, to serve as the chapel's pastor for the 1900–1901 season. Ward served the congregation for 30 years in addition to his responsibilities at Rollins.

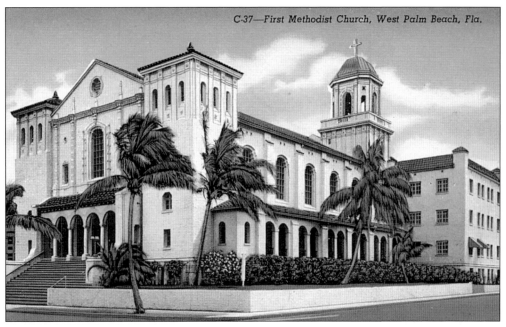

C-37—First Methodist Church, West Palm Beach, Fla.

Even though there was only a limited number of churches and synagogues on their little island, Palm Beachers didn't need to travel far to find their house of worship just across Lake Worth in West Palm Beach.

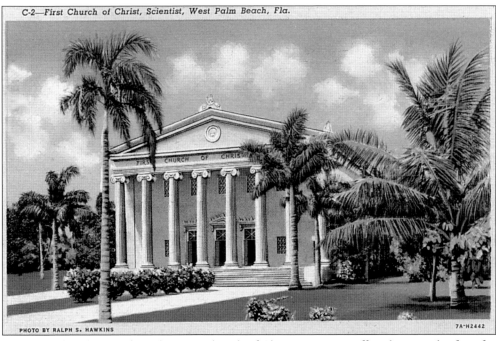

C-2—First Church of Christ, Scientist, West Palm Beach, Fla.

PHOTO BY RALPH S. HAWKINS

7A-H2442

Mainland churches, such as the First Church of Christ, Scientist, offered spiritual refuge for worshippers of many Christian and Jewish denominations as well as other religions.

111

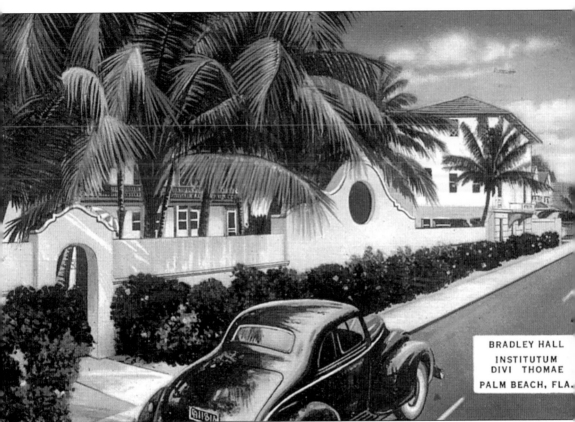

BRADLEY HALL
INSTITUTUM
DIVI THOMAE
PALM BEACH, FLA.

The Institutum Divi Thomae was a graduate-level institution for biological scientific research founded in 1935 by Cincinnati Archbishop John T. McNicholas and Dr. George Sperti. One of the college's main research focuses was cancer, and its Palm Beach headquarters gave it a beautiful base of operations.

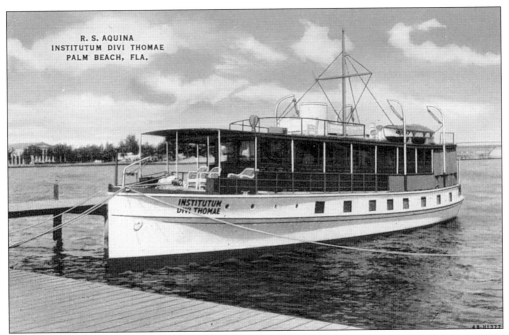

R. S. AQUINA
INSTITUTUM DIVI THOMAE
PALM BEACH, FLA.

The research vessel *Aquina*, at 75 feet long, 17 feet wide, and powered by twin 150-horsepower diesel engines, was the home on water for Institutum Divi Thomae's researchers. The vessel's laboratory facilities were located at the rear of the main deck.

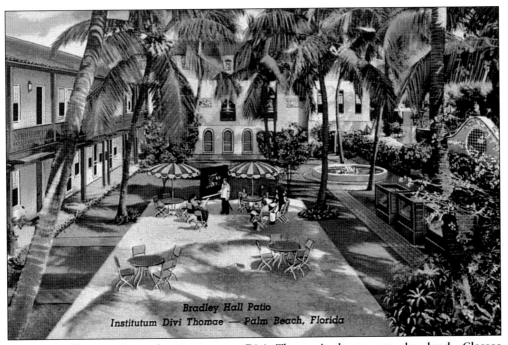

Bradley Hall Patio
Institutum Divi Thomae — Palm Beach, Florida

Bradley Hall served as the Institutum Divi Thomae's home on dry land. Classes often were conducted outdoors. The patio area also was home to several aquariums for the researchers.

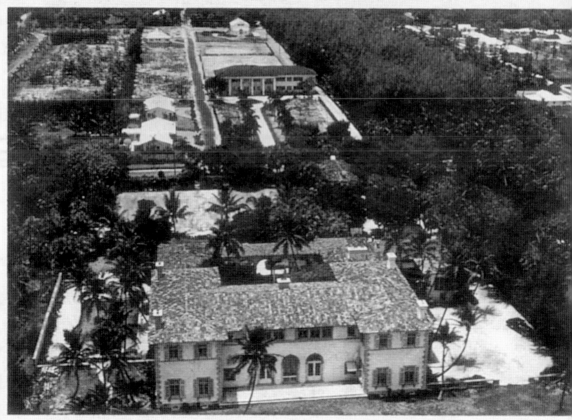

An aerial view of the Graham-Eckes School, now called Graham-Eckes Palm Beach Academy. Former Flying Burrito Brother Gram Parsons is among the students who attended. Graham-Eckes Palm Beach Academy, Palm Beach Day School, and a public school are among the schools serving the island's youths.

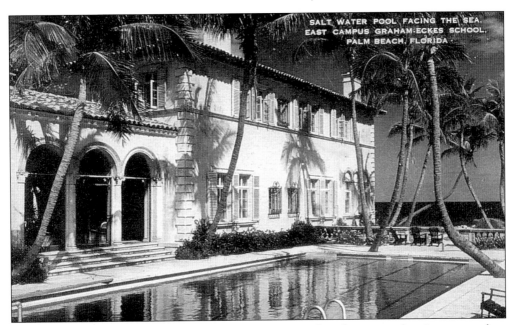

Graham-Eckes School shares the Mediterranean Revival architecture that is so prevalent throughout the island. This is a view of the school's east campus, looking toward the ocean.

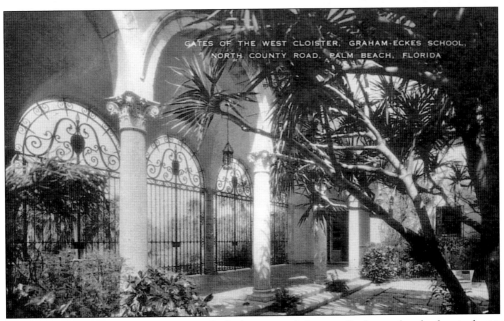

This is a view of the dracena-shaded west cloister of the school, located on North County Road.

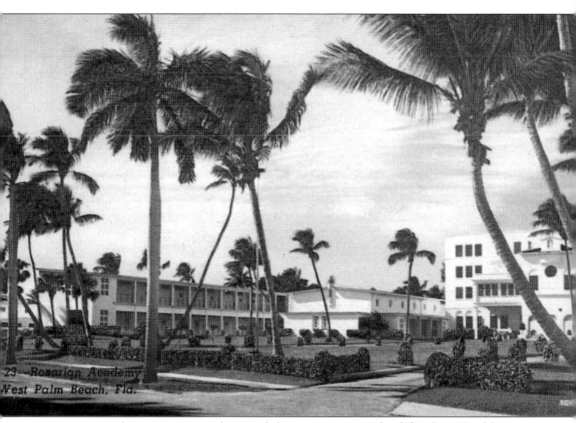

23—Rosarian Academy
West Palm Beach, Fla.

Rosarian Academy is in West Palm Beach but serves many island families. Notable among Rosarian's graduates is LPGA golfer Michelle McGann. Other private schools serving Palm Beach students include Cardinal Newman High, The King's Academy, Lake Worth Christian School, and Benjamin School. Additionally, Palm Beach Atlantic College is located just across Lake Worth in the heart of downtown West Palm Beach.

Nine

ISLAND LIFE

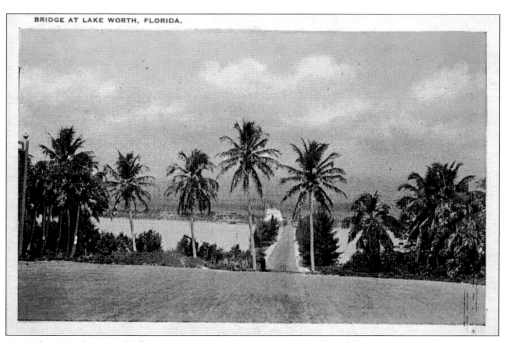

BRIDGE AT LAKE WORTH, FLORIDA.

On Palm Beach, a real-life Fantasy Island, every day is a day of dreams. From the moment the sun rises and makes the heavens blush, until after it sets, every day bubbles with adventure and promise.

ke Worth, Palm Beach, Fla.

During its Golden Age, a typical day on the island might have included a long, leisurely stroll along the beach or a leisurely ride along the Lake Trail, which ran along the west shore of the island around Lake Worth. Lake Worth was the focal point of a variety of boating

activities, including regattas and races. In 1911, all eyes looked to the sky as a test pilot for Curtiss Aircraft, James McCurdy, flew his airplane low over Lake Worth near the Royal Poinciana Hotel, thrilling the hotel guests and those on the Lake Trail.

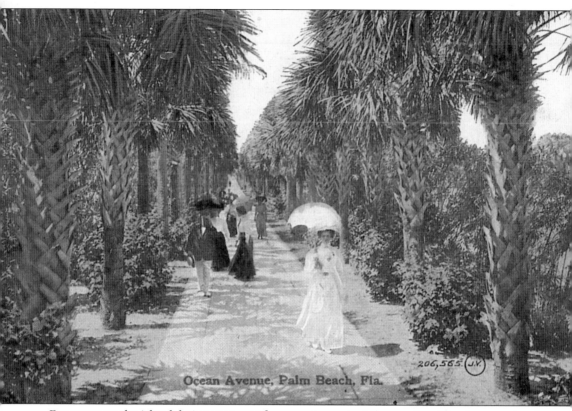

Ocean Avenue, Palm Beach, Fla.

For many on the island, being seen was far more important than seeing. The day was simply not without a promenade down Ocean Avenue in one's best resort finery with a parasol to repel the rays of the sun. During those days, a tan was looked upon as undesirable, symbolic of having to labor in the sun. A pale complexion with a slight healthy blush symbolized having lived the good life.

For those hearty souls who journeyed south for the season and brought their boat from home (or had friends who did), an afternoon spent cruising along the Intracoastal Waterway enjoying the sights, or out on the ocean in the company of friends, could prove most relaxing. A fleet of pleasure craft also was available for hire and ferry service also was available.

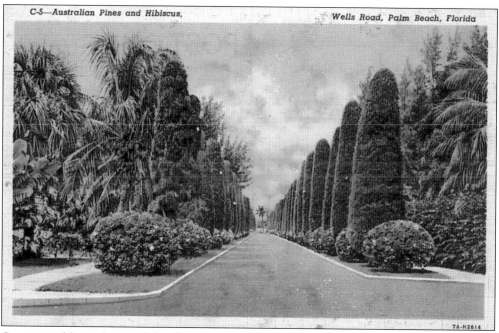

C-5—*Australian Pines and Hibiscus,* *Wells Road, Palm Beach, Florida*

7A-H2614

Or one could simply spend the day seeing the sights. Along Wells Road in the northern part of the island, the city maintained a beautiful stretch of roadway, planted with beautifully sculpted Australian pines, hibiscus plants imported from Hawaii, the omnipresent coconut palms, palmetto, and other exotic plants such as philodendron (*Philodendron selloum*) and monstera (*Monstera deliciosa*).

A BEAUTY SPOT, PALM BEACH, FLA.

93853

Quite simply, Palm Beach represented beauty, whether made by nature and maintained by man, or created by man and enhanced by nature. Wherever one turned one's attention on this real-life Fantasy Island, there was beauty.

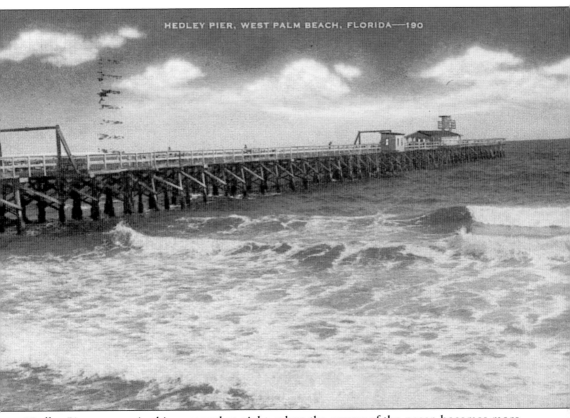

Hedley Pier appears in this postcard at night, when the power of the ocean becomes more visible and impressive. Occasionally, those visiting Palm Beach got a chance to see the ocean at its most impressive, when an occasional storm blew in. The most churned up things get is occasionally during hurricane season, which runs from June 1 through November.

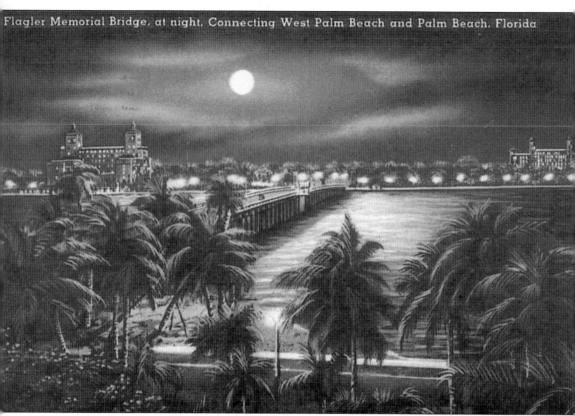

Flagler Memorial Bridge, at night, Connecting West Palm Beach and Palm Beach, Florida

When the sun goes down, the tempo of life on the island changes and Palm Beach undergoes a transformation, illuminated by the twinkling of thousands of street lights and brushed by swaying palm fronds. The island is bathed in the cool but bracing Atlantic breeze, which helps give residents and visitors alike a "second wind" for an evening out. Just as in the daytime, the list of possibilities is seemingly endless.

Among the most popular evening events during the season, formal balls and galas serve the purpose of providing entertainment for members of the island's social set but also for providing millions of dollars of support for a large variety of worthwhile causes. These galas also help inform participants about the benefits of philanthropy for these organizations.

Being seen at events—and seeing one's friends and enemies—is often as important as attending the performances at island cultural arts venues such as the Royal Poinciana Playhouse. For most participants in Palm Beach society, every stop of the evening requires a change of clothes to perfectly fit the occasion.

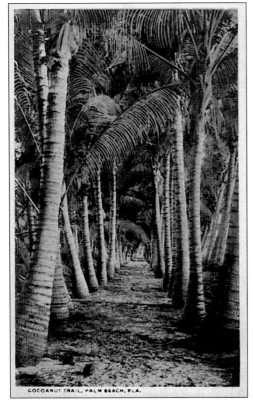

COCOANUT TRAIL, PALM BEACH, FLA.

But no matter one's activities or interests, on Palm Beach a coconut tree is never far away and serves as a reminder of the island's unique history and spectacular development.

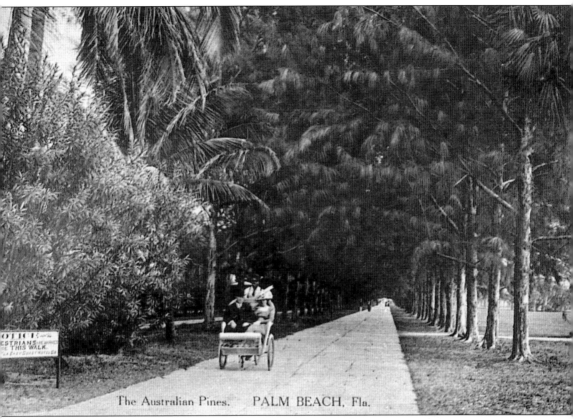

The Australian Pines. PALM BEACH, Fla.

Palm Beach is sometimes chided for its many rules, which have outlawed noisy tennis ball machines, a variety of types of businesses, shirtless joggers, and more. The tradition began back in Flagler's day and remains. On this postcard, the sign at the left reads as follows: "Notice: All pedestrians are urged not to use this walk."

Palm Beach - It's Wonderful!

But nearly everyone who visits this beautiful, enchanted island comes to agree enthusiastically, as Henry Flagler did, that Palm Beach is a place like none other. It remains a paradox for some but endures as a paradise on earth for many more.